Praise for Alice Sink's Writing

"Sink has taken her memories and channeled them into five years of research and writing that resulted in her...book *The Grit Behind the Miracle*, which chronicles the true story of the Infantile Paralysis Hospital that was built in 54 hours in 1944."
—Jill Doss-Raines, *Lexington Dispatch*

"Throughout the rare glimpses from 1900 to around the early 1950s, Sink stuck to one consistent theme in *Kernersville*. Sink portrayed...the sense of community."
—Brandon Keel, *Kernersville News*

"*Boarding House Reach* reminds us of one of the most important truths of life: There are no ordinary people! Every story here is fascinating—and every one importantly belongs to history."
—Fred Chappell

"Community abounds in a colorful new book about the history of North Carolina boarding houses—a traveler's guide to a lost place that was small-town and worldly at the same time."
—Lorraine Ahearn, *Greensboro News & Record*

"A very highly recommended addition for academic and community library collections, *Boarding House Reach* could serve as a template for similar studies for other states."
—*Midwest Book Review*

"*Hidden History of the Piedmont Triad* recounts a number of interesting stories from throughout the Triad—from historic people and places to lesser-known colorful slices of life."
—Jimmy Tomlin, *High Point Enterprise*

"[In *Hidden History of the Piedmont Triad*] Sink writes about Lexington's downtown dime stores. She describes how each counter was like a different department of the store, with a candy counter and comic book section popular with children…and makeup counters that carried old-fashioned items such as Tangee lipstick and Evening in Paris perfume."
—Vikki Broughton Hodges, *Dispatch*

"Did you know that a nightclub in High Point once hosted the likes of Ella Fitzgerald and Duke Ellington? Have you heard the story of Lexington native John Andrew Roman, put to death on circumstantial evidence, or the local World War II fighter plane pilot who flew eighty-two missions to prevent German fighters from attacking American bombers? These are but three of the many little-known stories…found in *Hidden History of the Piedmont Triad*."
—*Arbor Lamplighter*

"[*Hidden History of the Piedmont Triad*]…covers people, places and events that have been forgotten."
—Ryan Gay, lifestyles editor, *Kernersville News*

"In *Hidden History of the Piedmont Triad*, author Alice Sink rediscovers the quirky stories of the Piedmont Triad…tying North Carolina into the rest of world history."
—*Our State Magazine*

HIDDEN HISTORY

HISTORY

of

HILTON

HEAD

Alice E. Sink

Charleston — London

THE
History
PRESS

Published by The History Press
Charleston, SC 29403
www.historypress.net

Copyright © 2010 by Alice E. Sink
All rights reserved

Cover image: *Painted Harbor* by Jason Kravitz

All images are courtesy of the Library of Congress.

First published 2010
Second printing 2012
Third printing 2013

Manufactured in the United States

ISBN 978.1.59629.848.4

Library of Congress Cataloging-in-Publication Data

Sink, Alice E.
Hidden history of Hilton Head / Alice E. Sink.
p. cm.
Includes bibliographical references.
ISBN 978-1-59629-848-4
1. Hilton Head Island (S.C.)--History. 2. Hilton Head Island (S.C.)--Social life and
customs. 3. Hilton Head Island (S.C.)--Biography. I. Title.
F277.B3S56 2010
975.7'99--dc22
2010007818

For Sarah, my "best-est friend in the whole wide world" since our kindergarten days together many, many moons ago!

CONTENTS

CONTENTS

PREFACE

M any fine books have been written about Hilton Head Island, South Carolina. The formats of these volumes differ. Many texts follow some type of chronological order, beginning with geologic formation and prehistory facts and moving to modern times. Some are composed of both text and pictures, while others rely heavily on particular themes, such as plantation life, archeological discoveries and servant-slave issues. All are interesting and informative.

This book, *Hidden History of Hilton Head*, is different. It is not written in chronological order; instead, it includes "bits of this and tads of that"—mostly social history focusing on people, life ways, believe-it-or-not snippets and places. The word "hidden" has no derogatory or sinister undertone. These stories come from various sources, including interviews and research, and hopefully illuminate heretofore-unknown truths.

Interestingly, Hilton Head has been known as both Port Royal and Trench's Island, so direct quotations in this book will move from one name to the other. Spellings also differ, the most prevalent example being "Lowcountry," "Low Country" and "lowcountry." In addition, when early communities or military installations change names, I attempt to clarify these inconsistencies.

The Library of Congress images add an important visual dimension to the different true stories in this book. I chose these carefully, matching them with specifics in the text. Occasionally, however, there will be what I call generic scenes, and I admit that I did take a few minor liberties. For example,

a picture of a cotton field may not have been labeled for a specific and exact location, but I believe that Lowcountry cotton fields, slave cabins and lagoons cannot differ that greatly, and I have seen enough of each to argue that point!

ACKNOWLEDGEMENTS AND CONTRIBUTORS

Thank you to "the Gang" at Hilton Head for your friendship, true stories and ongoing support. You are the inspiration behind this book because you helped me better understand and appreciate the uniqueness of the history of this wonderful island.

To Leslie and George, Joan and Tony, Rose and Mike and Elizabeth—our Lawton Woods, Hilton Head Island neighbors and friends.

To Peggy and Mike, Marcia, Tara, D.D. Sue and Bill, Roxanne, Sue and Larry, Su-Su and Tony, Jacob, Jan and Ed, Barbara and John, Jean and Jim, Patsy and Bill, Jeff, Gail and Jack, "Sunburn" Merry and Scottie—the Beach Club regulars. And also to Liz, Kenny and Kristen—the Beach Club staff who put up with all our nonsense.

To Doe Wolfe, my surrogate mother, who opens her Hilton Head home, heart and memories to me, and Ethelyn Spencer, who has always kept me informed about *who was doing what* on the island.

To Richard Pattisall Jr., longtime resident, who gives me great leads about *what happened when* on the island. I appreciate your friendship and your moral support.

To Laura All, my editor at The History Press, who gave me guidance and answered all of my questions. Also, to Katie Parry, my publicist at The History Press, who continues to arrange presentations and book signings.

To the Beaufort County (Hilton Head) Library staff, who found for me valuable sources for the writing of this book; and the High Point University Smith Library staff—David, Mike, Nita and Stephanie—who answered all of my questions concerning copyright, Library of Congress pictures, downloading images and anything and everything I asked of them. I appreciate your interest and your help.

Part I

PEOPLE

CLARA BARTON

Clara Barton, universally associated with founding the American Red Cross and treating soldiers during the Civil War, lived on Hilton Head Island for about nine months in 1863. Documented facts indicate that her tenure here included more than nursing wounded soldiers; she also engaged in a poignant romantic relationship with the chief quartermaster, Colonel John H. Elwell of Cleveland, Ohio.

Arriving in April 1863 at the Port Royal military instillation, home to the Department of the South, Clara happily joined her brother, David. He was one of the newly appointed quartermasters, an officer responsible for food, clothing and equipment for the Eighteenth Army Corps troops. Clara's fifteen-year-old nephew, Steven, served in the military telegraph office at Port Royal.

Just three months later, on July 16, 1863, the Federals attacked Fort Wagner on Morris Island—near Hilton Head—but their attempt to capture the fort failed. Nevertheless, many soldiers died. Clara nursed and comforted injured survivors, consequently earning the title "angel of mercy" in the midst of death and destruction.

This humanitarian effort brought criticism from two different groups. The Sanitary Commission, touting its mission as chief distributor of war-relief supplies, and the Christian Commission, headed by Dorothea Dix

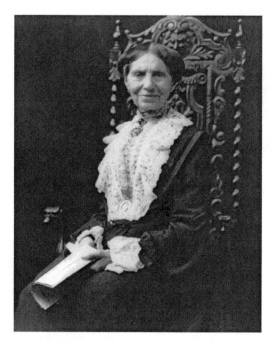

Clara Barton.

and claiming exclusive rights to offer "relief, sympathy, and the gospel" to soldiers, butted heads with Miss Barton. At first, army personnel supported these claims, expressing their mistrust of Clara because she always chose to work alone, but evidently all parties soon reconsidered, and Clara continued to aid and support the soldiers.

After the Fort Wagner battle, Clara remained in the area, where she continued to nurse the sick and wounded. She also assisted Frances ("Aunt Fanny") Gage and Frances's daughter, Mary, by teaching newly emancipated Port Royal slaves, abandoned by their plantation owners, to read, write and make a living. She wanted to protect their rich culture while helping them, now freed from bondage, earn a living. While at Port Royal, Clara ate with the officers and made many male friends. She spent her leisure time attending parties and dances and enjoying horseback riding. She also met and fell in love with Colonel Elwell. According to *The Biography of Clara Barton: "The True Heroine of the Age,"* Clara's spirit became rejuvenated:

> *She and Elwell discovered that they shared many common interests and, though he was married, became romantically involved. For a while Clara felt a strong connection with someone for the first time in her life.*

People

Elwell found himself mesmerized by this witty, intelligent, and courageous woman, and encouraged their relationship despite the impropriety of the situation. Albeit unconventional in her thought and demeanor, as a realist Clara knew their relationship could not last, and she did not wish to break up Elwell's marriage.

At first, the pair wrote chatty notes to each other, but soon they exchanged love letters. Clara knew that Elwell had a wife and family in Cincinnati, and she often talked of leaving Hilton Head; however, Elwell urged her to remain. She stayed.

Clara's rejuvenated spirit and love affair with Elwell may have been the first time in her forty-two years that she realized and confirmed her worth. Growing up as the youngest of five children in a volatile home environment, Clara endured her eccentric mother's fiery temper and constant squabbles with Clara's father, a miller and farmer. Consequently, Clara—tortured by her parents' verbal volleying and teased for her lisping—grew up shy and withdrawn. Her only ally, older sister Dolly, tried to protect and comfort her, but Dolly had a mental breakdown during Clara's sixth year, and her mother subsequently locked Dolly in an upstairs room.

Then, when brother David hurt himself at a construction site, eleven-year-old Clara nursed him for two years during his convalescence. After David recovered, Clara's inactivity brought depression, anxiety and a strong desire to be needed. Thus began her years of service as a teacher and then a nurse. Her love affair with Colonel Elwell, who admired her and found her verve and wit irresistible, may have convinced Clara that she indeed possessed charm and intellect, thereby instilling in her a sense of personal happiness.

Clara Barton left the Lowcountry in early 1864. For the remainder of the war, she nursed the wounded at Petersburg until the Confederacy's surrender at Appomattox Court House in April 1865. Later, she worked with the War Department in Annapolis, providing assistance for prisoners of war and recording and posting the names of missing soldiers. In 1893, she founded the American Red Cross.

Clara and Colonel John Elwell's romantic interlude ceased once they both left Hilton Head, their work completed. Their relationship became purely platonic from that point on, although they would always remain fond of each other as Clara performed public service and Elwell went home to his wife and family.

Clara Barton, American humanitarian, expressed her philosophy of life in the following words:

I have an almost complete disregard of precedent and a faith in the possibility of something better. It irritates me to be told how things always have been done…I defy the tyranny of precedent. I cannot afford the luxury of a closed mind. I go for anything new that might improve the past.

One might wonder if Clara's romantic island relationship with Colonel Elwell might have prompted this daring proclamation, changing the shy little lisping child into the modern woman who made important philanthropic accomplishments.

HARRIET TUBMAN

Although Harriet Tubman had a hard life as a young slave woman—or, perhaps, because her life was so difficult—she ultimately became a savior to other slaves.

Named Araminta by her parents, both slaves, and called Minty, Tubman was born in 1822, the fifth of nine children. When she was old enough to work, her owner hired her out to cruel masters. At one time during her teen years, an angry overseer threw an iron weight at another slave but missed. The weight hit Tubman in the head, causing lifelong seizures and headaches.

She married a free black man, John Tubman; at this time, she changed her name from Minty to Harriet.

In 1849, Tubman learned of an Underground Railroad on the Eastern Shore. She traveled at night with the North Star to guide her, and with the help of many people she did not know, she escaped to Pennsylvania. Over time, often disguised as a man, she was able to bring her family and friends to freedom. Tubman's eleven or more missions brought seventy people to safety and independence. Historians think that spirituals represented slaves' coded messages—understood by them but not their owners—and signaled those enslaved that an escape plan for them was in force. One of these songs was "Wade in the Water":

People

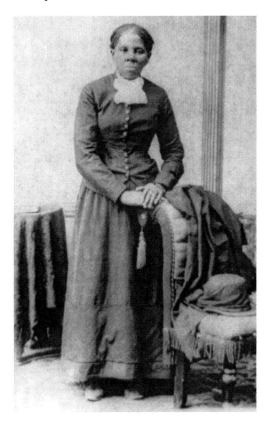

Harriet Tubman.

(Chorus)
Wade in the water.
Wade in the water, children.
Wade in the water.
God's gonna trouble the water.

Who's that young girl dress in white?
Wade in the water.
Must be the children of Israelites.
God's gonna trouble the water.

Jordan's water is chilly and cold.
God's gonna trouble the water.
It chills the body, but not the soul.
God's gonna trouble the water.

If you get there before I do.
God's gonna trouble the water.
Tell all of my friends I'm coming too.
God's gonna trouble the water.

Travelers on the Underground Railroad sang another song, "Follow the Drinking Gourd," and through it they shared their coded itinerary to freedom:

When the sun comes back,
And the first quail calls,
Follow the drinking gourd,
For the old man is waiting
For to carry you to freedom
If you follow the drinking gourd.

(Chorus)
Follow the drinking gourd,
Follow the drinking gourd,
For the old man is waiting
For to carry you to freedom
If you follow the drinking gourd.

The riverbank will make a very good road,
The dead trees show you the way.
Left foot, peg foot traveling on,
Following the drinking gourd.

The river ends between two hills,
Follow the drinking gourd,
There's another river on the other side,
Follow the drinking gourd.

When the great big river meets the little river,
Follow the drinking gourd.
For the old man is waiting
For to carry you to freedom.

18

By 1862, Tubman had targeted Port Royal, where she nursed black soldiers and newly freed slaves in Union camps. Eventually, her duties came to include spying, again sometimes disguised as a man. According to one historical report, she was an effective scout:

> *She became the first woman to command an armed military raid when she guided Col. James Montgomery and his 2nd South Carolina black regiment up the Combahee River, routing out Confederate outposts, destroying stockpiles of cotton, food and weapons, and liberating over 700 slaves.*

In 1867, her husband John was killed. She married Nelson Davis in 1869, and until the early 1900s, she spent her life appearing at local and national suffrage conventions. Harriet Tubman Davis died on March 10, 1913.

MARTINANGEL OF DAUFUSKIE

Word was out that the Tories on Daufuskie would attack. Gardner Plantation owner Charles Davant held 1,424 acres on the north side of Broad Creek, Hilton Head, and of course he was nervous about this news. A group of concerned men, including Davant and his friend John Andrews, saddled their horses and traveled to the Calibogue Sound. From their vantage point, they could actually see Daufuskie's shore. They most likely felt relieved when no one appeared, so they decided to return home.

Davant and Andrews rode their horses side by side. As they neared two huge oak trees, they thought they saw something moving; however, before they could determine whether the movement was human or simply Spanish moss blowing in the wind, a shot rang out. Charles Davant was hit. Before slumping in his saddle, he happened to look up and recognized his attacker—Martinangel of Daufuskie. He kept repeating aloud the name "Martinangel." He reached the yard of his house, and according to Virginia C. Holmgren, the following poignant scene occurred:

> *There on the piazza he saw his son rubbing his eyes sleepily, roused by the shot. With a scream of terror the lad ran to catch his father's blood-strained body as it slipped from the saddle. "Martinangel," the dying lips*

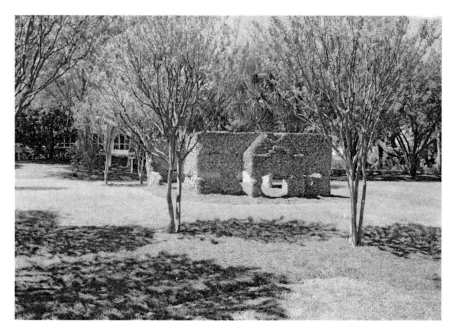

Daufuskie Landing's Haig Point tabby ruins.

murmured. "Get Martinangel." His son was only a boy, but he swore a man's oath. He would kill his father's murderer. He might have to wait until he grew bigger, but he would kill him. The men on Hilton Head Island in late December of that year 1791 did not wait. Their target was one man—the man named murderer by Charles Davant's last breath.

They killed Captain Martinangel and plundered the Martinangels of nearly all they had.

THOMAS WENTWORTH HIGGINSON

Many Civil War buffs would recognize Thomas Wentworth Higginson as an abolitionist minister who "served as colonel of the 1st South Carolina Volunteers, the first federally authorized African American regiment from 1862–1864." His regiment was the first to recruit former slaves; however, they had to be commanded by white officers.

People

Most people do not know of his personal life. Higginson was a published author. His book, *The Complete Civil War Journal and Selected Letters of Thomas Wentworth Higginson*, reveals interesting details about one of his boat trips:

> *Hilton Head lay on one side & the naval vessels on the other; all that was raw & bare in the low buildings of the new settlement softened into picturesqueness by the early light. Stars were still overhead, bulls wheeled and shrieked & above us the broad lagoon rippled... The air was cool as at home yet all the trees were green, glimpses of stiff tropical vegetation showed along the banks, with great clumps of some pale flowering shrub. Then appeared on a picturesque point an old plantation with decaying avenues and house & little church amid the woods like Virginia; & behind a broad encampment of white tents—and there said my companion is your regiment of Maroons.*

In his published account, Higginson recalls returning to camp at night and experiencing firsthand a circle of people engaged in their popular ring shout. He describes this religious fervor:

> *A circle of people moving in the rhythmical barbaric dance the negroes call a "shout," singing the music of their ceremony with the measured clapping of hands. As night wore on and the singing and dancing continued in deepening intensity...eventually everyone present, all ages, was "drawn into the vortex" of the music...the magical pull was an expression of traditional values of a people, those that moved the oldest to engage in sacred dance and the young to join them in the circle.*

It may come as a surprise that Higginson was literary mentor to Emily Dickinson. In an April 1862 *Atlantic Monthly* "Letter to a Young Contributor," he gave advice to the budding writer. Thirty-two-year-old Dickinson, from Amherst, Massachusetts, sent a letter to Higginson, enclosing four poems and asking, "Are you too deeply occupied to say if my Verse is alive?" He was not—his reply included gentle "surgery" (that is, criticism) of Dickinson's raw, odd verse, questions about Dickinson's personal and literary background and a request for more poems. Higginson's next reply contained high praise, causing Dickinson to respond that it "gave no drunkenness" only because she had "tasted rum before"; still, she had "few pleasures so deep as your opinion, and if I tried to thank you, my tears would block my tongue." But in

the same letter, Higginson warned her against publishing her poetry because of its unconventional form and style.

Perhaps Higginson's literary forte was writing dozens of spirituals. These were published, accompanied by the author's explanation of the inspiration behind the words. Many times, his musings are longer than the songs and come from true and unusual experiences. Such is the case with "The Driver." While Higginson was being rowed in a boat one day, he asked one of the oarsmen how he thought songs really originated. "Some good spirituals," the oarsman said,

> *are start jess out o' curiosity. I been-a-raise a sing, myself, once…Once we boys went for tote some rice, and de nigger-driver, he keep a-callin' on us; and I say, "O, de ole nigger-driver!" Den anudder said, "Fust ting my mammy tole me was, notin' so bad as nigger-driver." Den I made a sing, just puttin' a word, and den anudder word.*

This certainly piqued Thomas Higginson's curiosity, so he asked the man to sing, and when he did so, the other men in the boat joined in the chorus as though they had sung it many times.

> *Oh, de ole nigger-driver!*
> *O, gwine away!*
> *Fust ting my mammy tell me,*
> *O, gwine away!*
> *Tell me 'bout de nigger-driver,*
> *O, gwine away!*
> *Nigger-driver second devil,*
> *I'll build my house on Zion hill,*
> *O yes, Lord!*
> *No wind nor rain can blow me down,*
> *O yes, Lord!*

While it may not be terribly surprising to learn of Thomas Wentworth Higginson's abolitionist beliefs, military leadership and love of literature, the fact that he was a strong advocate of homeopathy may surprise some people. In an 1863 letter, he wrote the following tribute to Ms. Laura Towne, the homeopathic physician of his department: "I think she has done more

for me than anyone else by prescribing homeopathic arsenic as a tonic, one powder every day on rising, and it has already, I think (3 doses) affected me."

After the Civil War, Higginson devoted time to his writing and also became one of the founders of the Society of American Friends of Russian Freedom (SAFRF) in 1891 and, later, vice-president of that organization. He died on May 9, 1911.

Fred C. Hack

Fred C. Hack, son of a country doctor, trained as a surveyor, sawmill operator and timber scout. His experience, limited to the South Carolina and Georgia coasts, provided the foundation for his reputation as a responsible engineer. On December 20, 1949, Hack, a young lumberman from Hinesville, Georgia, who had learned that the south end of Hilton Head was for sale, made a quick trip to the island. He fell in love with the yellow pine timber he found in abundance. He purchased twenty thousand acres of pine forests, paying sixty dollars an acre. He calculated that he could profit quickly, yet at the same time, he realized that the beauty of the woods and marshes must not be destroyed in such a venture. Hack formed the Hilton Head Company with General Joseph B. Fraser, Olin T. McIntosh and C.C. Stebbins to accomplish his newly acquired dream. About two years later, in May 1951, a group of men—with Hack as their leader—formed another corporation, Honey Horn Plantation, and purchased more land, this time on the northern end of the island.

Fred Hack's philosophy and dreams still focused on a combination of preserving the island's natural beauty and maintaining historical interests, all the while bringing modern conveniences to make Hilton Head more accessible.

He brought in a group of scientists recommended by the University of South Carolina to study animal life. Hack was excited when the scientists identified two new subspecies, the island raccoon and island white-tailed deer. In addition, woodpeckers, painted bunting, night herons, cattle egrets, songbirds, shorebirds, waterfowl, hawks and owls were observed. Sea bass, whiting, winter trout, sheep head and other fish were abundant in the ocean.

Very soon, Hack moved his family to the island. He remodeled one of the existing Honey Horn houses, which he filled with recorded relics, including, according to Virginia C. Holmgren, the following artifacts:

the giant sized fossil tooth of a prehistoric mastodon unearthed by island road builders, an ancient canoe, Indian pottery fragments and shell tools, old coins, hand-blown bottles, stoneware jugs, inkwells, uniform buttons, old maps, diaries, newspaper clippings.

Hack's development of Port Royal Plantation began in 1962 on one thousand acres on the northeast corner of the island. Here, the former site of Civil War forts, were three miles of beachfront on the Atlantic and Port Royal Sound, lush woods, serene marshes and historic ruins in abundance.

Hack and his family most likely enjoyed eating Hoppin' John, a traditional New Year's Day Lowcountry dish.

HOPPIN' JOHN

1½ cups dried black-eyed peas
6 strips salt pork or bacon, diced
1 medium onion, chopped
2 cups cooked rice
Salt and pepper to taste
Dash of hot sauce
½ cup minced green onions, including tops

Rinse peas and pick them over. Cover with cold water. Add 1 tablespoon salt and let stand overnight. Drain peas, discarding water, and place in a 6- to 8-quart stockpot. In a 10-inch cast-iron skillet, sauté salt pork or bacon until crisp. Add it to the peas, reserving the droppings. Add onion, a little salt and 2 cups water. Bring just to a boil. Lower heat and simmer until peas are tender, about 20 minutes. A small amount of the cooking liquid should remain; if liquid is absorbed too quickly, add fresh water by ¼ cups. When peas are tender, add cooked rice to pot. Stir in 2 tablespoons of the reserved bacon drippings, salt, pepper and hot sauce to taste. Cover and simmer about 15 minutes longer so flavors combine and rice absorbs some of the remaining cooking liquid. To serve, garnish with green onions.

CHARLES E. FRASER

Charles E. Fraser, a native of Hinesville, Georgia, was, according to sources, "cosmopolitan and connected." A Yale-trained lawyer who had worked in Washington, D.C., and traveled widely, Charles was an intellectual, reader and dreamer, intoxicated with ideas. Fraser wanted to shift development away from the northern part of the island toward southern parcels; therefore, he formed the Sea Pines Plantation Company on the southern part of the island. Fraser and Fred Hack organized the Hilton Head Company in 1949.

Electricity was serving residents by 1951. Everything seemed to be coming together: ferry service had been established, the first real estate agency had been erected, the Sea Crest Motel was providing modest lodging for visitors and a bridge was completed in 1956, although dirt roads still provided the only trails to the beach. By 1957, one hundred simple beach cottages—with no air conditioning—had sprung up. The island also had two restaurants for whites and two for blacks, a couple of small motels, two churches and a nursery school. Norris and Lois Richardson invested $50,000 to open Forest Beach supermarket, but the bank loan was held up for almost a year because officials didn't think the island would "make it" as a resort.

Everything was looking good, but nobody knew what would happen next.

In 1969 and 1970, Fraser commissioned a study that showed "that golf's genesis in the United States took place in nearby Charleston, not in the Northeast as historians previously had asserted." Consequently, he paid close attention to the study and named the PGA Tour event he founded the Heritage Classic.

BENJAMIN HAYES VANDERVOORT

"Vandy" Vandervoort spent the last twenty-three years of his life at Hilton Head. An American soldier who had earned the rank of lieutenant colonel, Vandervoort fought in World War II and twice received the Distinguished Service Cross.

Born on March 3, 1917, in New York, he became a member of the 505th Parachute Infantry Regiment (PIR) of the 82nd Airborne Division in 1940, and his regiment was dropped over Sicily. On June 6, 1944, Lieutenant

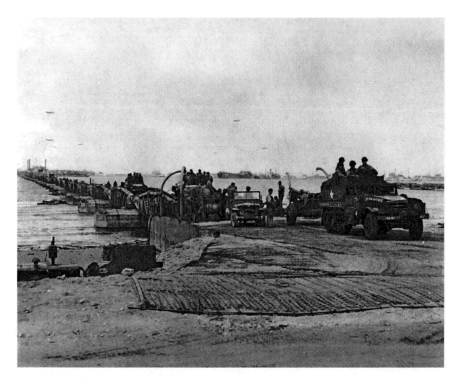

Tanks lined up for Normandy.

Colonel Vandervoort led the 2nd Battalion, 505th PIR airborne landings in Normandy, an event leading to the end of World War II in Europe.

General Matthew B. Ridgway described Vandervoort as "one of the bravest and toughest battle commanders I ever knew."

When "Vandy" died in 1990 at the age of seventy-three, his obituary revealed even more of his bravery:

> He broke his leg in the jump, but ordered a medical aide to lace his boot tightly so he could keep fighting a German counterattack on the Allied forces landing on Normandy beaches. He used a cane to stay in combat until the beachhead was secure.

An interesting aside concerning Vandervoort's toughness is probably not known by many people. Movie star John Wayne portrayed this brave man in Cornelius Ryan's history of D-day, *The Longest Day*. Oddly, Wayne was twenty-seven years older than Vandervoort had been on D-day, which made

him ten years younger than Wayne at the time of filming. Reports indicate another interesting snippet: "The role was actively sought by Charlton Heston, but the last-minute decision to tap John Wayne for the role in the film prevented Heston from participating."

Colonel Benjamin H. Vandervoort, World War II hero, resided in Hilton Head, where he died in 1990 at the age of seventy-five.

PRESIDENT BILL CLINTON

Renaissance Weekends at Hilton Head began in 1981 when sixty families got together for the first time to "learn from each other in a personal and substantive" way.

For fourteen years, Bill Clinton and his family, Hillary Rodham and Chelsea, rang in the New Year during Renaissance Weekend on Hilton Head Island. The December 28, 1991 issue of the *Washington Post* explains the event as follows:

> *Perhaps the best way to describe the gathering known as Renaissance Weekend that will be held on the South Carolina resort island of Hilton Head this week is to say that it is a Bill Clinton kind of thing. An extended weekend devoted entirely to schmoozing, to being serious here and sentimental there; to choosing up sides and topics and talking your heart out in a marathon gabfest of panel discussions, and listening, ever so earnestly; nodding and smiling, relaxed in bluejeans, wearing a big ol' name tag with your first name in GIANT letters dwarfing your probably famous surname, all equals here; a dawn-to-midnight exercise in empathy and enlightenment with hundreds of close friends.*

And there was more fun during the 1997 Renaissance Weekend, which included 470 families. The president began his day with a walk on the beach with his dog, Buddy, which wore a red leash with the wording, "I'm the one in charge." Next came a round of golf followed by a gala New Year's Eve party with other guests. A reporter asked Mr. Clinton if he had made any resolutions for the upcoming year, and the president's answer was, "I'm working on them—tomorrow."

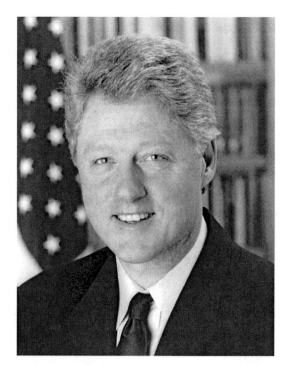

President Bill Clinton.

This New Year's tradition has continued through the decades, bringing together scores of distinguished participants. Attendees have included Nobel laureates; Pulitzer, MacArthur and Templeton Prize winners; dozens of Oscar, Emmy and Grammy winners; congressmen and governors; astronauts; former Republican and Democratic candidates for the U.S. presidency; and professional athletes. Even Dr. Ruth joined the group one year.

NOTABLE RESIDENTS

Many people will remember Robin Givens as Susanne on *The Cosby Show*, when she acted in the episode entitled "Theo and the Older Woman" (1985). She also played the character Ann on *Diff'rent Strokes* (1986) and Denise on *The Fresh Prince of Bel Air* (1995). Others might recall Givens's marriages to boxer Mike Tyson (1988) and her tennis instructor, Svetozar Marinkovic (1997), from whom she separated the same day they wed.

People

Hidden beneath her character roles and marriages is her eviction from posh Hilton Head. According to one 1995 printed source, Givens received the following court order:

> *Actress Robin Givens recently was ordered to vacate the premises of her $500,000 home in an exclusive private community in Hilton Head Island, SC, for owing nearly $13,000 in back fees. Ms. Givens, who was most recently seen in the TV movie* Dangerous Intentions *starring opposite Donna Mills and Corbin Bemsen, reportedly was $12,648 in arrears.*

Other famous full- or part-time residents include John V. Lindsay of New York City, who died on Hilton Head; Michael Jordan, former NBA player; Mark Messie, NHL hockey player; Stan Smith, former Wimbledon, U.S. Open and Davis Cup champ and tennis pro; Jim Ferree, American professional golfer who played on the PGA Tour and the Senior PGA Tour; Luke Kerr-Dineen, golfer extraordinaire; and Bobby Cremins, NCAA men's basketball coach.

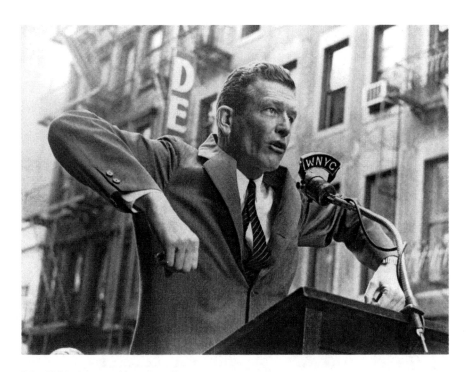

John V. Lindsay, speaking at a rally.

Entrepreneurs Arthur Blank, owner of the NFL Atlanta Falcons and Home Depot, and Cartha (Deke) Deloach, former high official in Hoover's FBI and senior vice-president of PepsiCo, call Hilton Head home.

Fiction writer Patricia Cornwell, mystery author Kathryn R. Wall, historical fiction writer John Jakes and singer-songwriters Duncan Sheik, John Cougar Mellencamp and Trevor Hall all have island connections.

JOHN GREENLEAF WHITTIER

Although poet John Greenleaf Whittier never actually visited Port Royal, one of his poems—"Song of the Negro Boatmen at Port Royal"—was praised by an abolitionist working there. He described the poem as "wonderfully applicable as we were being rowed across Hilton Head Harbor among United States gunboats."

John Greenleaf Whittier.

People

Written in dialect, this widely printed poem tells the story of Northern abolitionists coming as missionaries and teachers for the slaves who had been deserted by their owners.

Song of the Negro Boatmen at Port Royal, 1861

O, Praise an' tanks! De Lord he come
To set de people free;
An' massa tink it day ob doom,
An' we ob jubilee.
De Lord dat heap de Red Sea waves
He jus' as strong as den;
He say de word: we las' night slaves
Today, de Lord's freemen.
De yam will grow, de cotton blow,
We'll hab de rice an' corn:
O nebber you fear, if nebber you hear
De driver blow his horn!
Ole massa on he trabbels gone;
He leaf de land behind.

Whittier wrote several poems, all entitled "At Port Royal." The following one presents images of life on Hilton Head in 1861.

Iso at Port Royal

De Lord's breff blow him furder on,
Like corn-shuck in de wind.
We own de hoe, we own de plough,
We own de hands dat hold;
We sell de pig, we sell de cow,
But nebber chile be sold.
De yam will grow, de cotton blow,
We'll hab de rice an' corn:
O nebber you fear, if nebber you hear
De driver blow his horn!
We pray de Lord: he gib us signs

Dat some day we be free;
De norf-wind tell it to de pines,
De wild-duck to de sea;
We tink it when de church-bell ring,
We dream it in de dream;
De rice-bird mean it when he sing,
De eagle when he scream.
De yam will grow, de cotton blow,
We'll hab de rice an' corn.

John Greenleaf Whittier's ardent advocacy of the abolition of slavery in the United States is the theme of another poem:

152 at Port Royal

We dare not share the negro's trust,
Nor yet his hope deny;
We only know that God is just,
And every wrong shall die.
Rude seems the song; each swarthy face,
Flame-lighted, ruder still:
We start to think that hapless race
Must shape our good or ill;
That laws of changeless justice bind
Oppressor with oppressed;
And close as sin and suffering joined,
We march to Fate abreast.
Sing on, poor hearts! Your chant shall be
Our sign of blight or bloom,
The Vala-song of Liberty,
Or death-rune of our doom!

About 1845, worsening health and personal stress caused the poet's physical decline, thus ending his abolition activities. He died on September 7, 1892, in New Hampshire at a friend's home.

WILLIAM H. REYNOLDS AND EDWARD PIERCE AFTER THE CAPTURE OF PORT ROYAL

After the Federal army captured Port Royal on November 7, 1861, William H. Reynolds, lieutenant colonel of the First Regiment of Rhode Island Artillery, assumed responsibility for directing African American work. On January 1, 1862, Reynolds gave the following progress report to his superior, Secretary of the Treasury Salmon P. Chase:

> *I find on most of the Plantations corn, and Sweet Potatoes, in sufficient quantities to support the Negroes.*
>
> *I have made arrangements to furnish them with salt, molasses & other small stores in moderate quantities deducting the cost of these articles from the amt due them for labor…I find it is impossible to hire the Negroes by the day, on many of the Plantations, & have authorized my clerks to allow them a dollar for every four hundred pounds of stone cotton which they deliver at the steamboat landing, paying them partly in money & the bal in Clothing & Provisions.*

Generally, reports agree that many of the cotton agents who worked under Reynolds did not uphold his ideas of fairness,

The capture of Port Royal, 1861.

making the Negroes work without pay…and living upon "the fat of the lamb"—selling too, the sugar, etc. at rates most wicked, such as brown sugar, twenty-five cents a pound; using Government horses and carriages, furniture, corn, garden vegetables, etc.

Cotton agents were also slow to pay promised wages, resulting in difficulty getting the cotton ginned and to a New York market in a timely manner. William Reynolds's motives were more just than those of many who worked under him.

The Treasury Department appointed Edward L. Pierce, a young abolitionist from Boston, to remedy the labor situation. He immediately recognized many problems but quickly outlined the following plan and presented it to the secretary of the treasury:

Certain men, carefully chosen for the position, should be appointed to manage the cultivation of the plantations, their chief object being "to promote the moral and intellectual culture of the wards" and "to prepare them for useful and worthy citizenship."

Edward Pierce selected superintendents "as carefully as one would choose a guardian for his children." These men would receive a good salary. He suggested that the laborers' wages be forty cents a day, plus rations. Furthermore, he advocated bringing in teachers and missionaries. Ultimately, the Department of the Treasury did adopt Pierce's plan but had no money to back its support. Consequently, the Educational Commission and the Freedman's Relief Association volunteered funds for teachers and superintendents until the department received $200,000 from the sale of confiscated cotton to foot the bill for superintendents' salaries.

By mid-May 1861, Pierce "had received $10,000 to pay for labor and had spent $15,000 for implements, seeds, and mules, having purchased and sent to Port Royal ninety mules and ten horses." He also paid laborers "$1 an acre for all cotton planted."

Things seemed to be going fairly smoothly until an order came from Major General David Hunter, commander of the Department of the South. He declared, "All Negroes on the plantations between eighteen and forty-five able to bear arms…be sent forthwith to the camp at Hilton Head." As a result, Pierce lost approximately six hundred laborers who had to leave the fields—reportedly, without first going to their shacks:

*The Negroes were taken from the fields without being permitted to go
home for so much as a jacket...On some plantations the wailing and
screaming were loud and prolonged, and the women threw themselves in
despair upon the ground, while on other plantations where the news had
leaked out, the men took to the woods and the marshes, and had to be
hunted down by the soldiers.*

By June 1862, the Treasury Department had relinquished its duties
to the War Department to carry on the work that William Reynolds and
Edward Pierce had started. Pierce was offered an appointment with the War
Department but refused the job and promotion. No doubt, he suspected that
his plans and dreams would be altered.

MEN OF THE THIRD NEW HAMPSHIRE VOLUNTEER REGIMENT

The Third New Hampshire regiment arrived at Hilton Head in an attempt
to establish Federal footholds in August 1861. Earlier, on June 16, 1861, the
men had seen action in the Battle of Secessionville "with 26 officers and 597
men. 104 casualties resulted, with 27 men killed or mortally wounded."

Perhaps the most exciting venture of General Alfred Terry of Hilton
Head did not include war tragedy or maneuvers but something people would
least expect. He is famous for authorizing a famous band's move to Hilton
Head on March 10, 1863. A little more than a month later, Gustavus W.
Ingalls, former leader of the band of the Third New Hampshire Volunteers,
arrived on the island with his sixteen musicians, "drawing much attention
to [themselves] by [their] superior qualities, and on many occasions of
ceremony being accorded the place of honor."

By September 1863, General Terry's recommendation that ten more
musicians be hired had received approval from the post commandant. The
band received many accolades:

*It performed excellent service, drawing much attention to itself by its
superior qualities, and on many occasions of ceremony being accorded the
place of honor. During a portion of its service a number of musicians*

were hired to increase the number and effectiveness, and at times there were soldiers detailed from regiments to further augment the band. A portion of the pay of the band was drawn from the Post fund at Hilton Head, and in this way it acquired for the time being the name of the "Post Band."

The Post Band performed for about two years, until its "nearly final effort at Fort Sumter, April 14, 1865, at the celebration of the restoration of the old flag. It was mustered out July 4, 1865 at Hilton Head." Then, after two different failed assaults on Fort Wagner, the entire regiment mustered out of Federal service on July 10, 1865, and received final discharges and payment.

GREGG RUSSELL

Hilton Head residents and visitors can find songwriter, singer, entertainer and actor Gregg Russell performing most evenings under Harbour Town's old Liberty oak tree. Writing and singing children's music for over twenty-five years and entertaining, to date, over three million fans, Gregg jokes with the kids he invites to center stage. When he asks their names, and the children respond with a "Taylor," "Madison" or "Cameron," he strums his guitar and begins chanting in that kid-friendly, funny voice, "Yuppity-do-da, yuppity-aye."

Gregg Russell is more than just fun. Most folks are not aware of his serious side and his involvement in charitable organizations. He and his wife, Linda, founded Hilton Head Heroes, which benefits ill children and their families:

In a world where heroes are few and far between, on Hilton Head Island, they are as plentiful as the sand dollars on the shore. They are Moms and Dads, aunts and uncles, children and grandparents. They own resort villas, restaurants, homes, bicycles and boogie boards. Through the Hilton Head Heroes program, they are able to share what they have with families who are similar to their own in every way, except that the families in the Hilton Head Heroes program are coping with the reality of having a seriously ill child.

Another of Gregg Russell's programs is humorously named Lids for Kids. Its mission is, however, extremely serious. This program gives baseball hats to kids who are undergoing chemotherapy treatments. So far, over one thousand hats have gone to children recovering from cancer.

This talented songwriter for the SCETV series *Dooley and Palms* and the guy who's been on stage with Steve Martin, George Burns and the Beach Boys feels called to create children's memories that will last a lifetime.

Part II

LIFE WAYS AND EVENTS

SEABROOK PLANTATION

In the South—and especially on Hilton Head Island—the word "plantation" automatically connotes images of a mansion with a wealthy landlord and his family living in the Big House filled with luxuries and surrounded by a romantic veranda. According to surviving records, that scenario never existed at Seabrook. This plantation served a variety of purposes. At times, it became a working farm, a military headquarters, a freedman's school and a home base for missionary teachers. African American occupants lived at Seabrook Plantation, first as slaves and later as freed people.

Because an 1804 fire destroyed most records, Seabrook Plantation remains partially shrouded in mystery, but some facts survived. Neither owner William Seabrook nor his widow, Elizabeth Emma, ever resided on Hilton Head. By 1860, the plantation was serving as an important docking area along the Skull Creek water route. Its approximately six hundred acres, valued at $15,000, were used to produce crops and care for animals. At this time, William and Elizabeth's son James raised cattle, corn, rice, cotton, peas, beans, Irish potatoes and sweet potatoes on the land. The farm also produced five hundred pounds of butter, twenty tons of hay, sixty pounds of beeswax and four hundred pounds of honey.

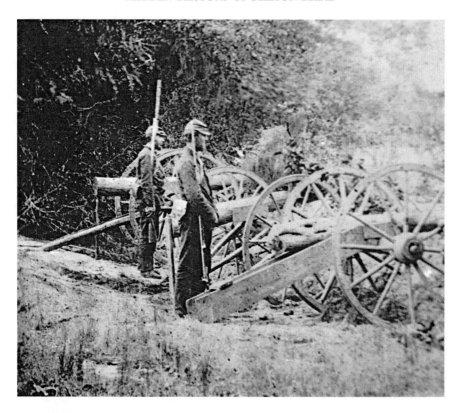

Seabrook Point.

Beginning about 1861, various regiments stationed to guard the Skull Creek frontier against Confederate intrusion used the plantation as a military headquarters. In 1862, the plantation consisted of the main house, approximately twenty-two servant or slave quarters and four storage units. That same year, the United States government purchased the entire piece of property at auction.

In 1867, two teachers—Charlotte M. Keith and Annie R. Wilkens—arrived at Seabrook Plantation under the auspice of the American Missionary Association to establish schools for the freed slaves. Although these two young women left no journals or diaries concerning their lodgings, one of the teachers at neighboring Lawton Plantation visited Charlotte and Annie and described in her diary what the main house looked like:

A little bit of a house with a single thickness of boards for sides and floors, not a bit of whitewash or plaster on the whole house and spaces between

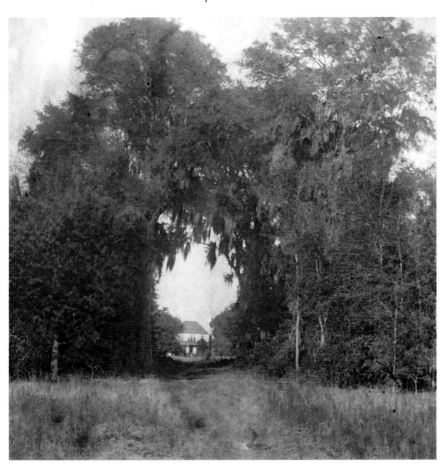

A natural arch at Seabrook Plantation.

the boards on the sides wide enough so the birds fly through. Stands on posts so that the air can circulate under; no cellar. The surrounding houses look like a barn on stilts, but the teachers' home is so small and light that the slightest wind shakes…One day we were there and were writing, the house shook so we could hardly make a straight mark. Thirteen of us ladies all slept in a small room. They had only three single beds in the house. These we ladies had and put them on the floor and laid our heads and part of our bodies on them. There were four in two of the beds and five in the one that I slept on. We had a hot fire in the fire place and the door closed and it did seem as if I should melt. We all took it as long as we could when four of us got up and went up stairs. We wrapped our water proofs around us and lay down upon a pile of corn husks.

A study entitled "From Summary and Synthesis of the Plantation Landscape: Slaves and Freedmen at Seabrook Plantation, Hilton Head" concluded that little could be learned about the main house because it had long since eroded into Skull Creek, so archaeologists focused on the two slave rows and discovered striking differences in the life ways of the inhabitants of each. The uniqueness of Seabrook Plantation became even more apparent during a 1994 archaeological excavation.

The northern slave row, situated to the rear of the main house, about two hundred feet away, was arranged in a straight line parallel to the property boundary and perpendicular to the main house. These shacks—framed with planks and with cladding (a layer of some metal or alloy bonded to another metal) for roofing—were probably inhabited by field and house slaves and abandoned after 1850. No window glass or plastered walls existed. Furnishings were sparse, although two high-status brass furniture artifacts suggest that slaves were given cast-off items, such as ceramics, from the main house. Slaves in the northern row had almost twice as many plates as bowls, an odd fact considering slaves' practice of eating stews, gruels and one-pot meals of beef, pork and mutton; obviously, slaves were given the less substantial cuts of beef, such as the head elements. Slaves in the northern row lived in dismal conditions.

The southern slave row was located approximately four hundred feet from the main house and five hundred feet from Seabrook Landing; it was isolated and arranged in a loose cluster around the marsh edge. Built about 1850 and occupied until near the turn of the century, the southern slave row represented the homes of artisan slaves, later freedmen.

The southern slave row excavation of two houses revealed that both had swept yards, shell middens within the yards, porches, fences and small outbuildings. The structures were raised on posts and had tabby chimneys at the southern gabled ends.

The Seabrook study made the following conclusion:

> *Inhabitants at the Southern Slave Row seem to have lived in slightly better conditions and exploited a greater range of the surrounding environment than the occupants of the Northern Slave Row. It is possible that the presence of more and different types of goods at the Southern Slave Row may have been a function of the increased availability of all goods due to the Union occupation of the sea islands and the ability*

of freedmen to participate in wage labor for cash, which facilitated the buying of such items. Structures in the Southern Slave Row had higher percentages of clothing and personal artifacts, such as buttons and jewelry. Padlocks and padlock fragments were found in the South Row, but not in the North, indicating inhabitants of the North either did not have ownership of their goods, were not concerned with the possibility of theft, or were not allowed to lock up their belongings. On the other hand, South Row inhabitants may have [valued] the ownership of their goods and wanted to protect them.

The report indicates important historical and archaeological truths about the freedmen's life ways at Seabrook Plantation.

LIFE AS ANTEBELLUM PLANTATION MISTRESSES

Some books and movies portray antebellum plantation mistresses as wealthy, regal and lazy. Although these women were often born into and reared by wealthy northern families, when they married at a young age and moved to the Lowcountry, including Hilton Head, their lives changed significantly. No longer were they pampered young women; they had to grow up quickly.

Usually their new environment, albeit it a plantation, was isolated from the social and cultural events they had found in Charleston. Transportation by barge, cart and carriage prevented them from experiencing frequent trips to a world to which they were accustomed. When they shopped on King Street in Charleston, they had been able to purchase items of clothing and accessories not available in Hilton Head, and they had attended teas and operas. They cherished occasional visits, but they willingly returned to their land, duties and homes. Plantation homes did not differ greatly in architecture. Most were large frame houses built on tall brick arches and surrounded with piazzas and double chimneys.

Plantation masters owned slaves, farmed cotton plantations, hunted and raised horses. Their wives had to learn to manage the day-to-day life of the plantation. From necessity, they also learned how to make medicines for the ill. These women, in charge of seeing that the slaves

Two women trimming a man's hair.

had clothing, supplies and food—made or grown locally—learned to cure meat and preserve vegetables and fruits. Apparently, they also became personal barbers.

Many times, transplanted northern mistresses retained their former interests in reading, gardening, singing and sewing and tried to fit these interests into their busy schedules of supervising their house servants. One Lowcountry mistress commented on this time-consuming, confusing duty:

> *Housekeeping is very different at the South from the North though I think one thing is, people here give themselves too much trouble about it and have a great many too many servants about the house which of course creates great confusion. For instance there are but four bedrooms to be attended to in the house and there are five chambermaids to attend to them, so of course that makes just five times as much confusion as is necessary.*

In addition to routine chores and duties, from 1861 to 1866 plantation mistresses also served in various ways to assist soldiers and make them feel welcomed.

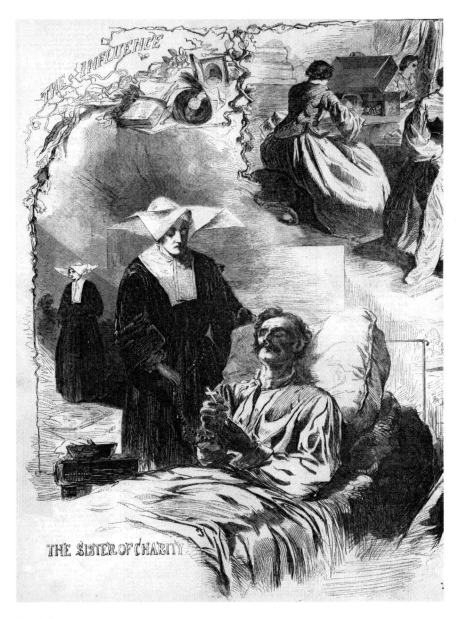

The influence of women.

Soldiers waving caps at a woman.

FREEHOLD OR CHATTEL

Most people know that South Carolina was a slave colony as early as 1526. The first Africans were purchased by white planters and taken to Hilton Head's indigo plantations to work these crops. Perhaps few know that there were actual laws to control the slaves. According to the Carolina Grand Council, slaves were considered freehold property rather than chattel:

> *Freehold property in theory could not be moved or sold from the estate, similar to the position of medieval serfs who were tied to specific farms or feudal estates. The slaveholder had use of an enslaved person's services, but could not claim absolute ownership. By 1696, however, the status of enslaved Africans in South Carolina had been degraded to chattel property in law and in practice. Enslaved blacks, mulattoes and American Indians could be bought and sold, and their children were enslaved for life.*

According to the code, an owner had to give written permission for a slave to be away from his plantation; otherwise, the slave was automatically considered a runaway. The first offense carried a whipping, slitting of the nose and burning of part of the face. If a slave escaped more than once, the owner branded an *R* on his cheek and sometimes also cut off an ear. A fourth attempt brought male castration or female branding of an *R* on her left cheek. Cutting the tendon in one leg or sentencing the slave to death was punishment for a fifth failed escape attempt. This law was modified in 1800, when the legislature demanded that owners gain approval for manumissions (the freeing of enslaved persons). Later, in 1820, slaves would be freed only by an act of the legislature.

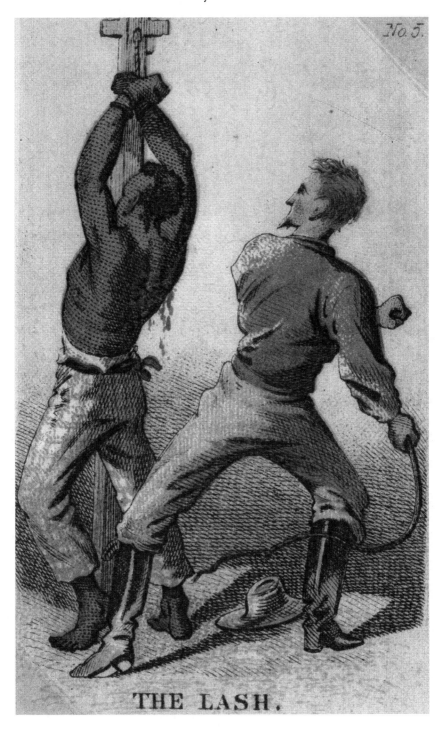

The lash.

In 1740, the Negro Act was passed. This prevented enslaved blacks from having any type of legal protection. In addition, this act required enslaved men and women to dress in coarse fabrics appropriate to their status; they could not learn to read or write or assemble with one another. Flogging was the usual punishment for disobeying these laws.

Prior to 1830, the Fugitive Slave Act was enforced to return slaves who tried to flee to the North. They were usually caught and returned to their

A cypress swamp.

southern owners. Not all were captured. Runaway slaves often sought refuge in a deserted swamp area. William Byrd discovered "a family of mullatoes [*sic*]" in 1728. He made the comment, "It is certain many slaves shelter themselves in this obscure part of the world." A 1784 observer gave more details:

> *Run-away Negroes have resided in these places for twelve, twenty, or thirty years and upwards, subsisting themselves in the swamp upon corn, hogs, and fowl, that they raised on some of the spots not perpetually under water…and on such spots they have erected habitations and cleared small fields around them; yet these have always been perfectly impenetrable to any of the inhabitants of the country around, even to those nearest to and best acquainted with the swamps.*

Those slaves who did escape to the swamps formed what are called "maroon communities," and these offered a new lifestyle for enslaved Africans in South Carolina. Here they could grow their food, they had abundant water and they built crude shelters. What they did not have—knives, pots, ammunition—they sometimes took by force from nearby plantations. Some black children who were born and grew up in the swamps never knew the terror of being owned.

In 1765, the governor of South Carolina sent a militia to one of the maroons, but the slaves escaped into the swamp and then relocated. Their

The Underground Railroad.

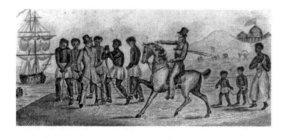

The United States slave trade.

A practical illustration of the Fugitive Slave Law.

former camp was described as "a Square consisting of four Houses 17 feet long & 14 wide...the kettles were upon the fire boiling rice & about 15 bushels of rough Rice Blankets Potts Pails Shoes Axes & many other Tools."

Until 1712, manumission was not regulated by statute, and by 1830, reports of marronage in South Carolina had dwindled, probably because escaping slaves could be freed "for good cause" but had to leave South Carolina within six months. Many did find new homes in the North.

SINGING SONGS OF PROTEST AND WORSHIP

Now, freemen, listen to my song, a story I'll relate,
It happened in the valley of the old Carolina State:
They marched me to the cotton field, at early break of day,
And worked me there till late sunset, without a cent of pay.

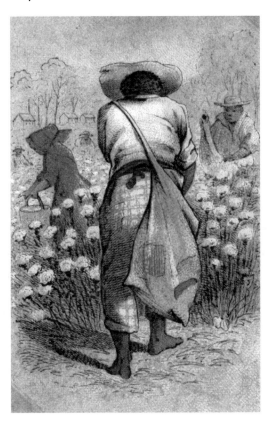

In the cotton field.

(Chorus)
They worked me all the day,
Without a bit of pay,
And believed me when I told them
That I would not run away.

Massa gave me a holiday, and said he'd give me more,
I thanked him very kindly, and shoved my boat from shore;
I drifted down the river, my heart was light and free.
I had my eye on the bright north star, and thought of liberty.

I jumped out of my good old boat and shoved it from the shore,
And traveled faster that night than I had ever done before;
I came up to a farmer's home, just at the break of day,
And saw a white man standing there, said he, "You are run away."

The interior of a slave cabin.

I told him I had left the whip, and baying of the hound,
To find a place where man was man, if such there could be found,
That I heard in Canada, all men were free
And that I was going there in search of liberty.

When slaves were gathered on Hilton Head to build Fort Walker for the Confederates, they started a song of protest. It went like this:

No more peck o' corn for me,
No more, no more;
No more peck o' corn for me,
Many thousand go.

No more driver's lash for me,
No more, no more;
No more driver's lash for me,
Many thousand go.

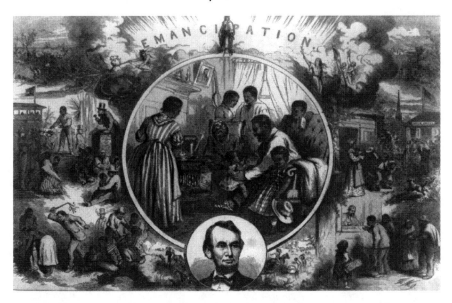

Emancipation.

Later, freed slaves (called contrabands) possessed almost all of the plantation system. They sold eggs, vegetables, turkeys and chickens to Northern soldiers and also sometimes taught them how to get fish, oysters, shrimp and crabs from the creeks and sea. The hundreds of contrabands on Hilton Head Island held their worship services in little gray, slab-sided "praise houses," where the original slaves worshipped. According to one historian, the songs of the freed slaves touched the hearts of many Northern soldiers:

> *It was not uncommon to find men seated in one of the big Sibley tents after supper, intent upon a reading aloud from the Bible. The basic Baptist fervor and the tremendous musical power of the freed slaves excited them far past their usual habits of observance, though, and they stayed and shouted, stamped and danced all night long at the praise house meetings. The soldiers learned several of the more popular spirituals, just by repetition alone.*

After the contrabands had been with the Federal troops at Hilton Head for some weeks, they were quite sure that they were free for good. They called one song "Pray On," and it went like this:

A Sibley tent.

Pray on—pray on;
Pray on, den light us over;
Pray on—pray on,
De Union break of day.
My sister, you come to see baptize
In de Union break of day,
In de Union break of day.

Yet another song went as follows:

Meet, O Lord;
Meet, O Lord, on de milk-white horse
An' de nineteen vial in his han'.

Drop on—drop on de crown on my head,
An' rolly in my Jesus arm;
In dat mornin' all day,
In dat mornin' all day,
In dat mornin' all day,
When Jesus de Christ been born.

Interestingly, early songs of both worship and protest arose as a result of African American enslavement. Songs, almost always accompanied by dance or movement, reflected a combination of slaves' religious values and their heritage, with roots in west and central Africa. The circle dance, also known as the "ring shout," consisted of a combination of movement and music. Because many masters did not sanction these ceremonies, slaves sometimes gathered far from the Big House in one of their cabins, according to one historical overview entitled "Spirituals, Praise Houses and Ring Shouts":

When the slave quarters was far enough away from the residence of the owners, Black people might gather in one of the cabins, moving to the side the meager furnishings so that a dance circle could form in the center of the room. The narratives of former slaves mention that a large tin basin was sometimes overturned and raised to the rafters to "catch sound" and lessen the likelihood that the gathering would be discovered. Or, the basin or barrel might be filled with water and set in the middle of the room or by the door in the belief that it could serve a similar purpose of dampening down the sound. When slaves had access to their own churches, with moveable benches or pews, the ring shout ceremonies often occurred there, after the formal "sermon" service was completed. But just as often people gather in woods bordering the plantations where they lived or in simply constructed "praise houses" or "hush harbors" or sometimes out in the open air around a fire. There they would raise up the song and move in an easy, slightly weighted step in a counterclockwise ring, starting with a slow tempo and gradually building to a cadence that featured the syncopation of handclaps, feet stomping and percussive sticks to keep and vary the rhythm. And in the repetition of the sung lines and the movement of the circling bodies, the spirit was called and answered.

Not all African Americans thought the ring dance was appropriate; for example, one pastor of the African Methodist Episcopal Church believed this practice to be a heathen custom. He complained to a local pastor, who reportedly told him, "Sinners won't get converted unless the spirit of God works upon people in different ways. At camp meeting there is a ring here, a ring there, a ring over yonder, or sinners will not get converted." The ring dance continued.

GULLAH CULTURE

The word "Gullah" refers to both people and language. Beginning in the late 1500s, Africans arrived in Hilton Head, but before they were taken from Africa, they were often kept in holding cells, where they originated a new language. This combination of languages and cultures became know as Gullah.

In Hilton Head, these Gullahs (also known as Geechees) knew how to grow rice and cotton and therefore were the most sought after. They were good workers; with their knowledge and muscle, they made their owners rich pre–Civil War farmers. In the eighteenth century, slaves often learned how to fish from Indians. One historian claims, "One Indian, or dexterous negroe [sic], will, with his gun and nets, get as much game and fish as five families can eat." Most of the time, slaves on rice plantations spent what precious spare time they had in canoes made from dugout tree trunks. Reports indicate that by the mid-eighteenth century, slaves and free blacks "had established a near-monopoly on the fishing trade in Lowcountry towns."

Men and women sometimes farmed their own small vegetable gardens, and by the end of the nineteenth century, they sold produce to local markets. In addition, they earned money by oystering and fishing.

These slaves brought many traditions from Africa. They believed that sweeping their yards kept snakes away, and they were experienced root-medicine practitioners, using witchcraft knowledge to help others. Today, many might be considered herbalists.

According to several different sources, children had duties and responsibilities but also homemade recreation. One slave narrative vivifies various South Carolina childhood experiences:

We used to ride cows to and from the pasture evey day. We allus minded dem and seed dat dey didn't want for no water nor nothin' in de hot summer time. In de winter, we'ud carry dem off to de cane brakes whar dey could eat de juicy little canes dat de fros' hadn't got ot. Long 'bout dat time o' de year, us big boys collected kinlin' wood fer de kitchen and fire places. We would git enough fer ou'n at de same time. Den we'un fotch white mud to de house for to keep de hearth white through de winter. Warm Sundays we would ketch de young billy goats and brake dem in to harness and wagon and ride dem. In de summer we'un spend Sundays a gwine in our old folks watermellow patches and gittin' plums and dewberries and de like o' dat. If de kotch us in de watermelons, dey would sho nuf who'rp us fer dat: les we had some ways to git out o' de scrape. But if we had fetched home any nice juicy plums or big black berries or de like, why, den it wuz hardly ever dat dey whorped us.

Consequently, the Gullahs, one of the oldest groups surviving today, were actually responsible for the success of the rice and cotton industries on the island. According to John Henrik Clarke, Gullah culture goes beyond crop successes. He states, "The survival of African people away from their ancestral home is one of the great acts of human endurance in the history of the world."

The following is a recipe for a modern version of Gullah crab cakes:

CRAB CAKES WITH SAUCE

1 lb. crabmeat	1 cup mayonnaise
1 cup Italian-style breadcrumbs	2 teaspoon. Worcestershire sauce
¼ cup mayonnaise	2 teaspoon. minced garlic
1 teaspoon. ground mustard	1 lemon, juiced
1 teaspoon. Worcestershire sauce	½ teaspoon. lemon zest
1 egg	3 cups vegetable oil
Salt and pepper to taste	

In a bowl, combine first 7 ingredients for the cakes. In a separate bowl, combine remaining ingredients—except the oil—to make a sauce. Divide crab cake mix into 4 patties. Add oil to a skillet. Fry the cakes for about 4 to 5 minutes on each side or until golden brown. Remove and let drain. Serve cakes topped with the sauce.

DIFFERENT POSES FOR DIFFERENT GENDERS

By the mid-1850s, Thomas Fenwick Drayton owned a mansion on Hilton Head, South Carolina. Drayton's slaves, soon to be freed by the Federal government, worked in the cotton fields. A great deal about these people is revealed in a photograph taken by Henry P. Moore in 1862. In fact, this image is studied by schoolchildren to determine the life ways of General Drayton's servants.

The Education Department of the J. Paul Getty Museum supplies the following information and questions for teaching specifics about this photograph. Students are asked to look closely at the picture and note as many details as they can. It is clear that all of the people in the photograph, except one, are black, and most are wearing similar clothing and accessories:

The mansion of the Rebel Thomas F. Drayton.

King Cotton.

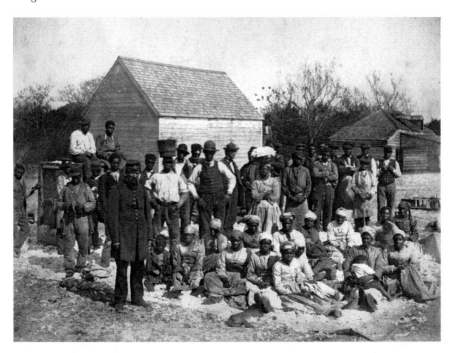

Drayton's slaves with cotton.

Several people have raw cotton stuck to their clothing. Women's heads are covered [with African-style wraps or kerchiefs], *which was a custom imposed on female slaves. The person in front is wearing a soldier's uniform. He is standing in the front as though he is overseer or master of the slaves behind him. How are the women posed differently from the men? Most are sitting down. What might this difference tell us about how women were viewed during the time when this photograph was taken? Women may have been considered inferior to men. On the other hand, they may have been considered more important or respected since they are positioned in front of the men and their seats on the ground could have been deemed more comfortable.*

Tarps and cotton covered the ground. Carts and wooden tools were built by the slaves. These were used for sorting cotton.

TRENCHES, OUTDOOR HEARTHS AND BURNED CORNCOBS

Housing

During the early part of the eighteenth century, Hilton Head slaves lived in thirteen- by nine-foot huts called "wall-trench structures" because the walls were mud and thatch. Upright poles set in a trench and covered with clay constituted the base of the hut. Palmetto fronds acted as roofs. These structures had earthen floors and lacked fireplaces. Windows were scarce, and when a hut did have a window, only a shutter closed out inclement weather. The walls were habitually attacked by termites, and the South Carolina humidity also took its toll on the shacks. Because the abodes were hot in the summer and cold in the winter, most of the slaves' activities took place outside, where they built outdoor hearths to prepare their meals. There is also archaeological evidence that slaves burned corncobs to keep away the bugs. Often called "African huts," some plantation owners objected to this name because they wanted no part of the African influence on their land.

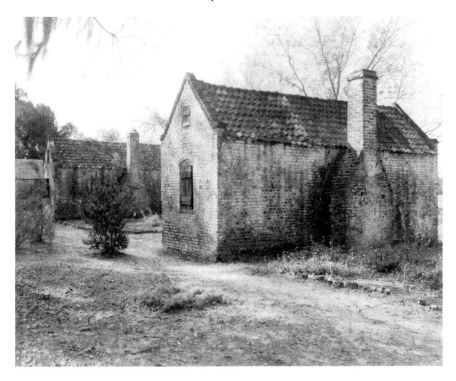

Slave quarters.

Food

Slaves ate selected plants and fish. When they did have meat, it was the bony cuts of skull, feet, jaw and legs. Popular were "one-pot" meals, with hog fat used as the sole seasoning. The stew simmered all day while slaves labored with their assigned tasks.

Personal Possessions

A few green glass bottles, possibly used to store water, wooden spoons and bowls, called colono ware, were used as vessels for the stew. Plates, glasses and cups were scarce. Lead fishing weights indicate that the slaves caught fish. Glass beads, copper wire and some buckles, buttons, pins and thimbles have been found. Kaolin tobacco pipes have appeared in various eighteenth-

century slave quarters. Furniture was rustic. Surprising is the fact that early eighteenth-century slaves had access to guns. It is believed slave owners provided them so that slaves could keep birds away from the crops and kill meat for the owner's table.

Organization

Research indicates that seasoned slaves, called drivers, trained others in the ways of plantation life, decided how many or how few rations to issue and meted out punishment for wrongdoings. They also taught newcomers to speak broken English and how to do menial chores such as gathering oyster shells for lime, preparing fields for planting and cutting wood. Next to drivers in authority came tradesmen, who included carpenters, plasters and chimney menders. House servants took care of most of the needs of the owners and their families and usually traveled with them to summer homes.

Field hands—anyone over fourteen years of age—worked preparing fields for planting, sewing seeds and harvesting crops.

Occasionally, of course, disputes arose and were settled, as in the following case:

> *The driver was refusing the* [field] *hand his peck of corn because he had been absent visiting his wife on a neighboring plantation when the corn was gathered, the work having been done after "gun shoot," as the Negroes termed the battle of Port Royal. The hand protested that he had helped to plant and hoe the corn and had been absent when it was gathered only because of sickness. Upon this evidence the (Federal) agent advised the driver to deal out the peck, and the driver promptly did so.*

Laborers quit their work at noon on Saturday. The roads became crowded on Saturday afternoons with people riding in carts or walking to the corner store, and Saturday nights were filled with dances or church meetings. Dr. J.M. Hawks, stationed at Port Royal, wrote to his wife:

> *Where I live, we* [sic] *the Negroes had a great celebration on the fourth, first at 6 A.M. raised a big flag to the top of the cupalo…Then they had a*

*regular barbecue—a beef was killed and roasted a la mode Southern. P.M.
dancing commenced and was kept up all the rest of the day. Our Supts. And
Schoolmaster and an officer joined in the dance.*

Freedmen, who now celebrated the Fourth of July, soon added Decoration
Day and Emancipation Day to their list of holidays.

Holy Matrimony

Slave weddings at Hilton Head were joyous occasions. Banquet foods
included cake, hams, turkeys and molasses. This was one of the few times
that slaves were allowed to partake of wine. The planter and his wife usually
joined in the festivities and furnished wedding cakes baked in the kitchen
of the Big House. Christmas was a popular time for young slave couples
to become engaged, with weddings planned for spring. Typically, the bride
and groom received a three-day wedding holiday from chores as a gift from
their master. An interesting fact, unknown by many, is that although South
Carolina law did not recognize slave marriages, ceremonies were usually
conducted by clergy. It's likely that planters, themselves Christians, wanted
to encourage matrimony among their slaves because they did not condone
living in sin, and they felt that family ties and commitments would ensure
peace and stability. Of course, the slave population would then increase
by the birth of babies. According to one account, "Thus, for reasons both
sincerely altruistic and at the same time self-serving, planters...actively
promoted slave marriage."

According to scanty documentation, the wedding couple's clothing did
not differ much from their normal garments. Women who were responsible
for spinning, dyeing and weaving provided the material. Seamstresses
worked full time, sewing the fabric into shirts, pants and dresses. The bride
and groom could not design their own garments; clothing served a purpose,
and only a few slaves "dressed beyond their station." Reports indicate that
only house servants had formal ceremonies, feasts and dances. Many simply
"jumped the broom"—literally jumping over a broomstick. This custom
varied in several ways, according to Reginald Washington in his article
"Sealing the Sacred Bonds of Holy Matrimony":

On some farms, the slave bride and groom would place separate brooms on the floor in front of each other. The couple would then step across the brooms at the same time joining hands to signal that they were truly married. On other farms, each slave partner was required to jump backward over a broom held a foot from the ground. If either partner failed to clear the broom successfully, the other partner would be declared the one who would rule or boss the household. If both partners cleared the broom without touching it, then there would be no "bossin."

Occasionally, the bride and groom were granted some favors on their special day. Reports describe brides' very short red and yellow worsted cotton skirts and large turbans. Grooms possibly wore a woolen suit with a "crocker sack or burlap" texture.

Slave weddings and feasts usually took place on the front lawns of the planters' plantations and, as one historian noted, "represented a focused gathering in which both blacks and whites on the plantations were engrossed in a common flow of activity. The weddings of slaves were sometimes occasions for great celebration." Conversely, other couples simply received their owners' permission to move into the same cabin.

CHRISTMAS WEEK

Although one historical drawing depicts slaves in formal evening clothes enjoying Christmas week, research does not document fancy evening dresses, satin slippers, tuxedos or leather boots. According to one historical report, the custom at Hilton Head was joyous but much simpler:

There was much feasting at Christmas, for a beef and several hogs were always killed and extra rations of sugar, coffee, molasses, and flour were given out, and great quantities of sweet potatoes. Black fiddlers demonstrated their style and flair with music while dancing servants performed. Altogether, it was a joyful time.

Even before the official three-day festivities began, the mistresses of various plantations went to each slave house and gave candy to the children.

African Americans at a
Christmas party.

*Then, on Christmas Eve, the planter and his wife took ham, goose, turkey,
salt, rice, and molasses to the adults, but especially welcomed were rarities
such as gingerbread, apples, currants, oranges, and plum pudding.*

Christmas was a time of fun for house servants, who took turns off
from their work. House servants were more respected than field servants
and considered special. They were in a position to knock at the Big House
door, enter the residence and proclaim, "Merry Christmas, Massa. Merry
Christmas, Miss." These slaves originated a game they played with their
master and mistress.

*House servants made a game of saying "Merry Christmas!" or "Christmas
gift!" before a member of the master's family did, followed by "I ketch uy!"
if successful. Upon being caught the member of the master's family was
expected to produce a gift, whereupon the slave would reciprocate with two,
three, six, or a dozen eggs wrapped in a handkerchief.*

The morning of December 25 was definitely a time for celebration, and music became an important part of the party. Slaves playing fiddles and drums accompanied dancers. Those who were native Africans often demonstrated their dance styles. Everyone enjoyed singing carols, repeating the same verse several times:

> *Brightly does the morning break*
> *In the eastern sky; awake!*
> *Cradled on his bed of hay,*
> *Jesus Christ was born today.*
> *Let a merry Christmas be,*
> *Massa, both to me and thee!*

On some plantations, Christmas Day was devoted to inspecting tools. Those slaves who had taken good care of their tools and had avoided trouble received rewards of an extra week's ration of meat, peas, rice and molasses. Women slaves were given, in addition to food, handkerchiefs, and men got woolen caps. Both received cast-off clothes from the Big House. A few plantations required that one of the three Christmas vacation days be spent cleaning cabins, but this was likely less backbreaking labor than fieldwork. All in all, research indicates that slaves generally enjoyed their three-day Christmas holiday.

On the plantation of General William Drayton, a reporter for the *New York Daily Tribune* witnessed the Christmas season of 1862. The heading read, "The Emancipated Slaves at Port Royal," and this Northern correspondent observed the following celebration:

> *Christmas Eve was celebrated by the colored people at Gen. Drayton's plantation. About 11 o'clock a bell was rung, and precisely at 12 a pine fire was kindled in front of the cabin where the meeting was to be held. They called the festival serenade to Jesus. One of the leaders, of which there were three, was dressed in a red coat with brass buttons, wearing white gloves. The females wore turbans made of cotton handkerchiefs. All ages were represented, from the child of one year to the old man of ninety.*

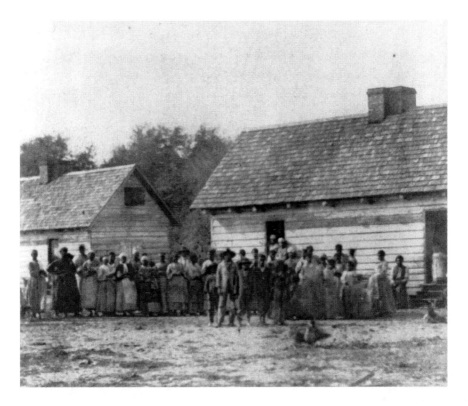

Slaves on Smith Plantation.

One historian notes that during their first Christmas as freed men and women, slaves sang together the words to their favorite hymn—"Say brothers, will you meet me on Canaan's happy Shore"—and probably reminisced about their old lives and rejoiced in the Federal command that now allowed them to buy the coffee they drank around the fires. Although the Drayton family was now gone from the plantation, some surely missed General Drayton because he and his son Thomas Fenwick had remained there faithfully "on the day of the big gun shoot," while another son, Percival, had taken the side of the Northern troops. Although life ways were changing during this 1862 holiday, former house slaves must have talked about the past and the separate paths of Thomas Fenwick and Percival Drayton, sons of their master:

It was said that, troubled by the great difference in their views, Thomas Fenwick Drayton and his brother, Percival, met in Charleston one night at St. Michael's Church. They spent the entire night shoulder to shoulder in prayer, but with dawn each went his separate way, and they were everlasting enemies.

These former slaves of the Drayton family grew vegetables and fished for the Federal troops on the island. Fathers could buy land and send their children to school. Families lived in government housing, and some even served in the First Regiment of South Carolina Volunteers.

The following recipe for Shrewsbury Cake is a modern version of one derived from an original used for long-ago Lowcountry Christmases:

SHREWSBURY CAKE

½ cup butter
2 eggs
1¼ cups sugar
1¼ teaspoon rosewater
4 teaspoons oil
4 teaspoon cinnamon
4 cups flour

In an electric mixer, combine the butter, eggs, sugar, rosewater and oil. Add the cinnamon and flour, mixing thoroughly to form a stiff dough. Divide the dough into 3 parts and form each of these into a 12-inch-long triangular log. Wrap these in plaster wrap and refrigerate overnight. The next day, when you are ready to bake these "cakes," cut the logs into thin ⅛- to ¼-inch slices. Place them on a baking sheet and bake at 375 degrees Fahrenheit for 12 to 15 minutes. (Note: Look for rosewater at a store that sells aromatherapy products.)

PORT ROYAL EXPERIMENT

In 1863, the United States government confiscated Lawton Plantation's eighteen hundred acres for nonpayment of taxes and paid the purchase price of $3,000. The problem was, who would be responsible for the welfare of the thousands of freed slaves? Enter the Port Royal Experiment, which provided a system whereby freedmen would learn to care for themselves, their families and their crops.

Four years later, in January 1867, Eliza Ann Summers and Julia Benedict, both teachers in their early twenties, left New York for the South Carolina Sea Islands. When these two young women reached Hilton Head Island, an agent of the American Missionary Association met their boat and transported them to Lawton Plantation, where, for the next six months, they lived and conducted day school, evening school, sewing school and Sunday school.

Lawton Plantation, surrounded on the southeast by the Atlantic Ocean and on the northwest by Calibogue Sound, consisted of a main house and fifty cabins, or quarters, where the natives lived. Initially, Eliza and Julia found the plantation house—built on posts—roomy and comfortable; they had four sparsely furnished rooms on the lower level and two rooms upstairs that opened to a veranda. A cistern outside provided cool, clear and refreshing water. Their servant, Susie, whom they hired for eight dollars a month, cleaned, cooked and washed and ironed their clothes. Mr. Elmore, a freedman, became the young women's protector, helper and friend. He ensured their safety, provided dressed robins for their breakfast and made a wooden stool for their sitting room.

Then the rats invaded the house. At night, they came from their holes, bounding unabashedly—almost human-like—across the wood floors with potatoes in their mouths. Eliza and Julia started taking their shoes to bed with them so they would have something to throw at the thieves. In a letter to her sister, Eliza complained that a rat even carried off her silk watch cord. Other problems arose as well. The women encountered rattlesnakes, experienced severe thunderstorms, suffered from mosquito and flea bites and went long periods of time without a grain of flour in the house.

Eliza and Julia, who viewed these hazards as mere inconveniences, focused on their work to help the freedmen and their families gain the

Playful rats!

various skills they needed to lead productive and independent lives. The plantation "praise house," or church, doubled as a makeshift schoolhouse. During the day, the island children learned fundamentals, beginning with the alphabet; in the evening, adults gathered after a day of fieldwork to learn to write and also to receive garden seeds from New York and instructions for planting. Ultimately, the natives grew their own crops—new potatoes, turnips, radishes and green peas—to supplement the crabs, prawns (island shrimp) and oysters they gathered from the Broad River, the plentiful soups and steaks from island turtles and the plums and blackberries growing wild in the brambles.

Occasional outings to visit nearby teachers associated with the American Missionary Association gave Eliza and Julia a respite from their daily routine at Lawton Plantation. A sailing excursion to Bay Point and a visit to the lighthouse there provided a chance to socialize and enjoy a picnic lunch of sandwiches, doughnuts, boiled eggs, sardines, cakes, pickles, olives, cider and cold coffee followed by a shell-hunting excursion on the beach. The teachers especially enjoyed their trip to "Daw Fuskie" Island, where they picked roses

as large as tea saucers, and they found their horseback-riding afternoons at Braddock's Point invigorating. After a trip to Bluffton, they marveled at the beauty of the village but were saddened to learn that the 150 children there had never had a school.

One of the highlights of social life at Lawton Plantation occurred when the servant, Susie, announced her engagement. Eliza and Julia offered their sitting room for her June wedding, helped her make her dress and put themselves in charge of baking and decorating her wedding cake. Susie's generous intended, Mr. Graham, presented his bride-to-be with gifts of "a nice pair of stays, a hair net, pair of stockings, muslin for a sacque, a ring, four tumblers, and a goblet."

Although the two young women accomplished a great deal at Lawton Plantation, letters reveal their displeasure with the dictates issued by Mr. Judkins, superintendent of the American Missionary Association, who decreed that the teachers must retire at 9:00 p.m. and rise for breakfast at 6:00 a.m. He also limited visits from young men and set specific hours for calling. He lectured Eliza and Julia on economy and chastised them for spending twenty-eight dollars in one month. The action that most aggravated the young women came when Mr. Judkins insisted they both prove their reading skills by reading aloud a long printed speech.

Both Eliza and Julia chose to go back to their Connecticut homes on June 20, 1867, at the end of their six-month contract, but they left behind natives who could now read, write, sew and farm.

Seven years after Eliza and Julia's departures, Martha S. and Joseph A. Lawton redeemed their land, paying $600.47. The last known record concerning Lawton Plantation comes from a 1962 description referring to a "weed-covered open space and what was left of a large brick fireplace and chimney foundation and the magnificent oaks still standing at the end of the road which leads toward the marsh from Six Oaks Cemetery."

Today, the old plantation's main house, all of the freedmen quarters and even the praise house have fallen into total decay. Not even the fireplace and chimney remnants remain. The cemetery still lies beneath the beautiful old oaks, which stand strong and tall. If they could talk, they would tell of two young women who made a difference on the island over 132 years ago. And if you listen very carefully and the wind blows just right, you might hear faint echoes of children singing spirituals just before sunset.

Eliza and Julia probably ate many bowls of Susie's Limpin' Susan. (Legend has it that Limpin' Susan was the wife of Hoppin' John.)

Limpin' Susan

¼ cup green bell pepper, diced
¼ cup yellow onion, diced
3 tablespoons vegetable oil
2 cloves garlic, minced
1 cup long-grain white rice
2 cups chicken stock
Ground black pepper and cayenne pepper to taste
1 teaspoon salt
1 pound shrimp, peeled

In a 12-inch cast-iron skillet over medium heat, sauté the onion and pepper in the oil until soft, about 5 minutes. Add the garlic and sauté for 2 minutes, being careful not to burn it. Add the rice, stir with a fork until the grains are coated and cook, stirring often, about 3 to 4 minutes or until rice is opaque. Add the okra, stock, salt, black pepper and cayenne pepper and bring to a boil. Reheat to low and simmer, covered, until the rice is tender and the liquid has been absorbed, about 20 minutes. Adjust seasonings, stir in the shrimp and cook until the shrimp curl and turn pink, about 6 minutes. Transfer to a bowl and serve.

SHARECROPPERS

After the Civil War, tenant farming developed because freed ex-slaves moved to farms where owners shared in harvests. According to reports, blacks accounted for almost 70 percent of sharecroppers in South Carolina. Assigned a cabin and "40 acres and a mule," they provided labor and, by 1920, shared in the harvests. Later, white tenants entered into sharecropping agreements with Hilton Head landowners. Planters issued credit at their commissionaires throughout the year, waiting for the crops to be sold so tenants could have supplies throughout the year.

Life Ways and Events

The South Carolina Writers' Project initiated a Life History Project in 1938. An interview with Mattie Mammond Harrell reveals an interesting social history not found in textbooks. Mattie finished fifth grade in a one-room school and admits that she "took to learning." Her remembrance of childhood fun is amazing. She talks about games such as baseball and drop the handkerchief (with which many of us are familiar) and then informs her interviewer of one of her favorites—marching on the level:

In this game the players clasp hands and form a circle, leaving one player in the center as "It." Then they begin marching around and singing:

> *"We're marching on the level,*
> *We're marching on the level,*
> *We're marching on the level,*
> *For we have gained the day."*

Raising their clasped hands, they continue singing while the player in the center goes in and out of the circle, passing under the joined hands.

> *"Go in and out your windows,*
> *Go in and out your windows,*
> *Go in and out your windows,*
> *For you have gained the day."*

Then, as the player enters the last window:

> *"Go forth and face your lover,*
> *Go forth and face your lover,*
> *Go forth and face your lover*
> *For you have gained the day."*

"It" uses his arms as a measure, and the players sing:

> *"I measure my love to show you,*
> *I measure my love to show you,*
> *I measure my love to show you,*
> *For you have gained the day."*

Both "It" and "the lover" kneel.

> *"I kneel because I love you,*
> *I kneel because I love you,*
> *I kneel because I love you,*
> *For you have gained the day."*

Rising, they continue:

> *"I rise because I love you,*
> *I rise because I love you,*
> *I rise because I love you,*
> *For we have gained the day."*

As the song ends, "the lovers" change places, and the song and marching begin again.

When Mattie married, she and her husband became sharecroppers on ten acres of land. Their income from healthy cotton crops (before the boll weevil came into the state) provided them with necessities and, occasionally, a piece of furniture. Mattie gave birth to three children while she and her husband sharecropped, and for several months during each pregnancy, she was unable to help with the work on the farm. Married only five years before her husband died, Mattie took her children and moved back to her father's land, where all of them hoed and picked cotton.

Even as an adult, Mattie enjoyed sugar cane grindings and watching the youngsters play games such as tag and "there ain't no bears out tonight."

MITCHELVILLE'S ESTABLISHMENT OF GOVERNMENTAL RULES AND REGULATIONS

Some people do not know that the town of Mitchelville became what is called a dress rehearsal for Reconstruction. In 1861, the white residents fled, and several Northern charities aided former slaves in becoming self-sufficient. When he was eighty-seven years old, Sam Mitchel recalled the day the Union fleet forced the Confederate army to retreat:

Maussa had nine children, six boy [sic] *been in Rebel army. Dat Wednesday in November w'en gun fust shoot to Bay Pin* [Point] *I t'ought it been t'under rolling, but day ain't no cloud. My mother say, "son, dat ain't no t'under, dat Yankee come to gib you Freedom." I been so glad, I jump up and down and run. My father been splitting rail and Maussa come from Beaufort in de carriage and ear by him yelling for de driver. He told de driver to git his eight-oar boat name* Tarrify *and carry him to Charleston. My father he run to his house and tell myh mother what Maussa say. My mother say, "You ain't gonna row no boat to Charleston, you go out dat back door and keep agoing." So my father he did so.*

Two days later, the Union soldiers declared victory. One Union soldier recalled slaves escaping to the Union camp, "many of them with no clothing other than gunny-sacks." While these slaves were not yet freed, the Union army considered them to be contrabands of war and often encouraged Confederate owners to reclaim their property and take them back to a life of slavery.

In 1862, General Ormsby Mitchel led African Americans to found the community of Mitchelville on Hilton Head Island. That same year, the government of the village was established:

The government was to establish schools for the education of children and other persons. To prevent and punish vagrancy, idleness and crime. To punish licentiousness, drunkenness, offenses against public decency and good order, and petty violation of the rights of property and person. To require due observance of the Lord's Day. To collect fines and penalties. To punish offenses against village ordinances. To settle and determine disputes concerning claims for wages, personal property, and controversies between debtor and creditor. To levy and collect taxes to defray the expenses of government, and for the support of schools. To lay out, regulate and clean the streets. To establish wholesale sanitary regulations for the prevention of disease. To appoint officers, places and times for the holding of elections. To compensate municipal officers, and to regulate all other matters affecting the well-being of the citizens, and good order of society.

According to historical records, four stores opened but two closed, "perhaps for cheating the residents." Merchandise offered in the stores included "coffee pots, buckets, tin pie plates, tableware, frying pans, shovels, brooms and brushes, fish seines, shirts, pants, suspenders, cloth, cologne, hair combs, belts, thimbles, buttons, bonnets, bead necklaces, condensed milk, dried peaches, tobacco, pipes, flour, grits, butter, lard, rice, and soap."

A February 7, 1863 article entitled "Port Royal, S.C.," published in *Frank Leslie's Illustrated Newspaper*, notes General Mitchel's intentions:

> *To try the effect of voluntary labor, he made arrangements for the building of a number of little cottages for the colored people…It is situated on Hilton Head Island, and presents ever* [sic] *evening scenes of remarkable gaiety.*

Freedmen desired work because they wanted to buy goods such as basic kitchens utensils, household furniture and clothing. Working for the Union army, former slaves earned between four and twelve dollars per month. Today, artifacts include bowls, slate pencils for writing on slate tablets, Union buttons and white ware cups, probably purchased from one of the early stores in Mitchelville.

This new community was located along today's Beach City Road.

OYSTER SHUCKING IN BLUFFTON

While in the Lowcountry, tourists seek fresh oysters. If they are adventurous, they will open the shells—after receiving specific instructions from their server. There is a correct way to hold the shell (upside-down) in one hand. In the other (toweled) hand, one holds an oyster knife and wedges it into the hinges that connect the shell. With a turn of the knife between the shells, one removes the upper shell and runs the knife under the meat to release it. This is "doable" for a small bucket of oysters.

At the turn of the twentieth century, men, women and children shucked oysters at Bluffton's Varn & Platt Canning Company. While smaller children were able to shuck only a couple of pots a day, teens could fill ten or more

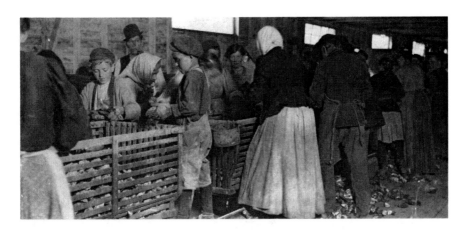

Shuckers' "finger-stalls."

Seven-year-old Rosie.

Housing for shuckers.

pots daily, and the adults worked from 4:00 a.m. until dark because this was the best-paying company in Bluffton. A husband-and-wife team made about fifteen dollars a week. Working as long as fourteen to sixteen hours each day, adult shuckers suffered what they called "finger-stalls," or sore fingers, as a result of the rough, dirty shells.

Interestingly, it was unusual to find African American children employed at the Varn & Platt Canning Company although their parents worked there. Conversely, children of Caucasian parents worked at the cannery. Seven-year-old Rosie could shuck only a couple of pots each day, but she stayed at the cannery the entire time her parents worked. She passed the time by playing with her homemade doll.

Even with steady work, adults who shucked at maximum speed could afford only meager housing. In fact, their primitive abodes might be called shacks.

DEEP FRIED OYSTERS

60 medium-sized oysters, freshly shucked	*1½ cups plain flour*
Vegetable oil for deep frying	*1½ teaspoons salt*
2 medium eggs	*½ teaspoon freshly*
2 tablespoons water	*ground black*
	pepper
Horseradish sauce, to taste	*Pinch of cayenne*

Drain the oysters. Preheat the vegetable oil in deep fryer to 375 degrees. Combine the eggs, water and horseradish sauce. In a bowl, combine flour, salt, black pepper and cayenne and mix well. Dip the oysters in the egg mixture and then in seasoned flour to coat. Place side by side, but not touching, on a platter and allow to dry for a few minutes. When ready to fry the oysters, dip again in seasoned flour. Fry in batches of about half a dozen for 3 minutes or until golden brown. Drain oysters by placing on a platter lined with paper towels.

JACKS-ASHORE

After the Civil War, the area we now refer to as Hilton Head Island was sometimes called Port Royal. Northern men in patrol squadrons, responsible for capturing blockade-runners, enjoyed their free time ashore. After landing at the wharf at Port Royal, these men—collectively call "Jacks-ashore"—followed the railroad tracks to civilization and checked in at the Port Royal House for what we know now as R&R.

In 1862 and 1863, Port Royal House met the description and definition of a nineteenth-century southern boarding house. Touted as the tallest building ever constructed at historic Port Royal, the four-story frame house stood on one corner of Union Square. Wide latticed porches overlooked Port Royal Sound, and a multitude of windows, with wooden shutters opened, allowed refreshing coastal breezes to circulate throughout the upstairs rooms.

Sailors paid a nominal amount for bed and board. Accommodations were crowded, with as many as six men sleeping in one room. Although no definitive records exist concerning exactly who did the cooking and serving

A dock built by Federal troops at Hilton Head.

of meals, we can safely bet that newly freed female slaves provided three meals a day, cleaned the house and changed bed linens.

To entertain themselves during the day, Jacks-ashore enjoyed daily treks to Sutlers' Row, jokingly called "robbers' row," a line of tents or palmetto-thatched shacks. In order to know which goods were offered for sale, men purchased a copy of Joseph H. Sears's Saturday edition of the *New South*, whose nickel sheet advertised what sutlers had available on robbers' row. It did not take them long to learn that they could surreptitiously purchase one drink of whiskey from the robust, red-faced village butcher who kept his stash deep in the icehouse behind his shop. For additional pleasures, all

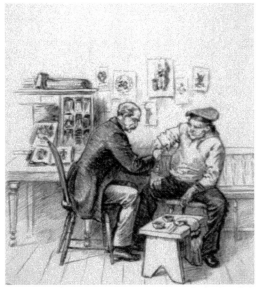

Left: A tattoo artist.
Below: A sutler's tent.

Jacks-ashore could visit other tents or shacks, which sold gallon jugs of gin and rum, chewing tobacco, snuff or cigars labeled Manila, Domestic, Cuba, Havana and Strong. They passed by the bakery and smelled the freshly baked bread. They also strolled in front of the post office and newspaper shop, all situated on Union Square.

Jacks-ashore purchased imported perfumes and beautifully decorated and scented notepaper to impress their ladies back home. Their next stop might have been the Beard and Company, where they had their photographs taken as a pictorial token of wartime adventures.

Interestingly, each business displayed a sign: NO TRUST. Merchants never sold their wares on credit.

Dressed in wide-bottomed blue trousers, the Jacks-ashore headed straight for the costly tattooer, where they chose a symbol representing family at home or women met at a previous port. Anchors, hearts, ships and flowers became popular icons, most of the time embossed with the man's initials. These markings not only satisfied seaman-like pride but also served a utilitarian purpose. If a sailor became hurt, thrown overboard or killed, his shipmates could easily identify him by these distinctive markings.

With their money spent, the sailors—their bodies now saturated with alcoholic beverages—staggered through Union Square to watch their competitors, the soldiers on the island, as they strutted down the steps of their headquarters. Army officers, dressed in sashes and big spurs and outfitted with swords and gauntlets, put on an impressive show as they jumped on their horses and galloped away from the sailors, whom they scorned because they believed these men had joined the navy solely to garner prize money for capturing blockade-runners. According to historical reports, Jacks-ashore relished revealing their sterling battle records to the soldiers and enjoyed arguing about anchor size and gun caliber. Unfortunately, they were outnumbered by army soldiers, so their voices were frequently ignored.

Not intimidated by what they perceived as army conceit, Jacks-ashore, their caps stuffed with snuff cans and chewing tobacco, walked to the wharf to watch tugboats in the harbor and to verbalize their envy of tugboat crews having no real chores and being able to fish all day. After a quick dip in the surf, sailors on leave might take a steamer to Beaufort, where they enjoyed a dinner of ham, chicken, green peas, yams and okra. As darkness descended, the steamer *Courier* headed along the river back to Hilton Head and Port Royal House, where sailors slept two or three men to a bed, awakened the next morning to a bountiful breakfast and then resumed their daily trek about robbers' row.

Today, Robber's Row, a golf course designed by George W. Cobb and built in 1963, cuts through magnolias and live oaks atop former Civil War grounds. Historical markers describe events of long ago.

Chicken Oscar is a Lowcountry dish Jacks-ashore may have enjoyed.

CHICKEN OSCAR

4 cups water, to boil asparagus
20 thin asparagus spears, trimmed and peeled
4 boneless, skinless chicken breast halves
¼ cup flour
½ teaspoon salt
½ teaspoon freshly ground black pepper
2 teaspoons butter
2 tablespoons vegetable oil
1 small red onion, chopped
1 medium tomato, chopped
6 ounces jumbo fresh lump crabmeat, picked over for shells and cartilage
2 tablespoons butter
¼ cup fresh lemon juice
2 cups plus 2 tablespoons whipped cream cheese
2 tablespoons milk
2 tablespoons fresh chives, chopped
8 cherry tomatoes, for garnish

In medium saucepan, bring water mixed with 2 teaspoons salt to boil. As soon as the water comes to a boil, add asparagus and boil until tender, about 3 minutes. Drain. Set aside until needed.

Lay chicken breasts between sheets of plastic wrap and pound to ½-inch thickness. On a medium plate, mix flour with ½ teaspoon salt and pepper; dredge chicken to coat, patting off any excess.

In medium, nonstick fry pan over medium heat, warm butter and oil. Sauté chicken breasts on both sides until browned and firm, about 3 minutes per side. Remove chicken; keep warm until ready to serve. Add onion to skillet and sauté until softened, about 4 minutes. Increase heat to high, add tomato and sauté until most of the moisture has evaporated. Lower heat to low and add crabmeat; toss gently, just until hot.

In small saucepan over low heat, melt 2 tablespoons butter with lemon juice to make sauce. Whisk in cream cheese, milk and chives until smooth. To serve, set one chicken breast on each plate and arrange asparagus spears on top. Spoon some of crab mixture over asparagus and drizzle with lemon chive sauce. Garnish with cherry tomatoes.

THE GAME OF BRAG

In the nineteenth century, Hilton Head gentlemen enjoyed playing a game of brag, an early form of poker. The word "brag" means "vie" or "bluff," according to one poker historian, who explains the rules:

> [This is] *a game played by five with a short pack of 22 cards, or by six with one of 26, four of which—the black Jacks and the red Nines—were known as "braggers" and could represent anything, including themselves. The first round of betting was followed by a "draw" to give each player a chance to improve a pair to a pair-royal or a lone card to a pair or pair-royal by discarding and "taking in" fresh replacements from stock…Brag was mostly played with all 52 cards.*

The game of brag first became popular in England, reaching the Lowcountry during the late colonial period, and was popular entertainment at many plantations.

The game of brag.

The card game became a familiar metaphor for artists as they referred to the 1848 election, as indicated in the picture on page 84.

The major contenders play a game of "brag." Around the table sit six players (left to right): South Carolina senator John Calhoun, Democratic presidential nominee Lewis Cass, Henry Clay, Whig candidate Zachary Taylor, Secretary of State James Buchanan, and President James K. Polk. In the center of the table is the "Presidenntial Ante." Displaying three aces, former Mexican War general Taylor exclaims, "Three bullets, Clay! Still at my old trade! Whenever bullets are to be met I am sure to have a hand with them!" Clay, who holds three low cards behind his back, replies, "I tried my old bluffing game with a contented hand & nothing to brag with but a hand full of hearts! I'm not sorry however that old Zach has won!" Seated to the left Cass laments, "Three braggers, Calhoun, woul'n't carry me through!" Calhoun, looking over Cass's shoulder, agrees, "No, Cass the Ante is too high for you! You'll have to play for smaller Stakes!" At the far right end of the table, Polk exclaims, "My knave hand, Buchanan, has lost me the game! I may as well slope!" Buchanan replies, "By Jove! Polk, Old Zack's got the documents! Three natties!"

This satire, according to one source, probably appeared before Martin Van Buren became a third-party candidate and after the June Whig convention, when Taylor was nominated over Henry Clay.

Part III

BELIEVE IT OR NOT

EARLY TIMELINE OF HILTON HEAD

In 8000 BC (Native American occupation), Paleo-Indians lived in this area and hunted the mastodon, a large, elephant-like mammal. They had shaggy coats, thick legs and long curving jaw tusks. They weighed about four to six tons. Their teeth were rounded and pointed, suited to crushing stems, leaves and other foliage.

In 1562 (European explorers era), Jean Ribault led French Huguenots into Port Royal Sound to establish the first Protestant settlement in the United States, but eventually everyone abandoned the settlement. Natives built fishing canoes by burning and scraping with seashells dugout tree trunks. In 1591, the French were still exploring Port Royal.

In 1663, Captain William Hilton (for whom Hilton Head is named) came to the area from Barbados to explore lands King Charles II had granted to the eight Lords Proprietors. John Bayley, an Irishman, was given the biggest portion of Hilton Head as a barony. It may surprise you that "for a short time, Hilton Head was called Trench's Island on some 18th century maps."

Tuscarora Jack Barnwell became Hilton Head's first white settler at Myrtle Bank Plantation in 1717 (plantation era). Today, Myrtle Bank is part of Hilton Head Plantation.

Ancient bones of mastodons.

A fossil mastodon skull showing teeth in diggings.

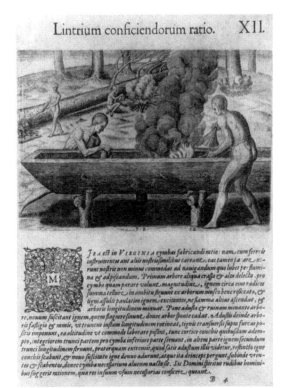

Lintrium conficiendorum ratio. XII.

Native men making dugout boats by burning and scraping tree trunks with seashells.

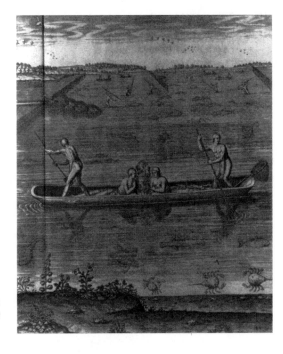

Native men and women fishing in a dugout canoe while others in the background stand in the river and spear fish.

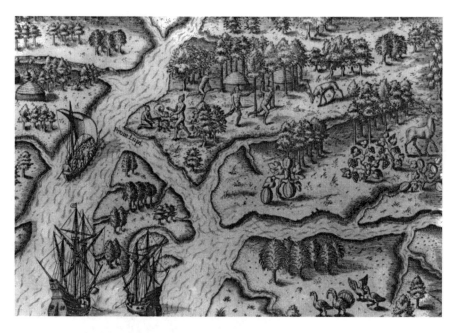

Habitat, wildlife and native encampment (1591).

By the 1750s, Sea Island plantations were growing indigo, and bricks of the dye were sold to the English. Just ten years later, in the 1760s, "the deepwater creeks around Hilton Head and the prevalence of hardwoods (like live oak) made the island a popular place for shipbuilding."

In 1861 (during the Civil War and Union occupation), Fort Walker was built on Hilton Head Island in order to protect the port from Union attacks. At this time, Hilton Head was also referred to as Port Royal. The next year, 1862, the cotton campaign increased as workers gathered, ginned, packed and shipped the cotton crops for the Federal army, under General Sherman, at Port Royal. Then came the Reconstruction and isolation period and the original school for freed slaves, which eventually became the Technical College of the Low Country by 1972.

From 1949 through the 1900s (mainland connection and modern era), Hilton Head slowly came to resemble what residents and guests see today—gates, golf courses, resorts, medical facilities, academies and time-share condominiums.

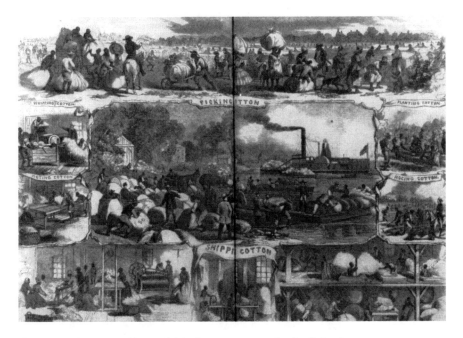

Gathering, ginning, packing and shipping cotton crops for the Federal army.

MYSTERY OF THE SHELL RINGS

Hidden history left by our ancestors abounds in various shapes and forms. From Egyptian pyramids to Stonehenge to French cave paintings, curious folks attempt to unlock their mysteries.

Hilton Head's prehistoric civilization also left secrets: shell rings. Just as old as the pyramids, these circles, composed of native animal bones and seashells, are believed to date back to 1450 BC. Theories differ concerning the reasons for their construction; however, according to one report:

> *The most plausible theory is that the ancients, for lack of a better idea, simply piled their garbage around their homes and camps, thus creating a circular trash heap, around a common area, thus recycling their refuse into a fence and boundary marker that could have also served as protection from wild animals, strong winds and other tribes.*

Stonehenge, Salisbury, England.

While four shell rings originally existed on Hilton Head Island, two were destroyed, supposedly to harvest the shells to make tabby. Local historians believe that remnants of the two destroyed rings are part of Baynard ruins in Sea Pines. An interesting aside to these ruins is the colorful legend surrounding William Eddings Baynard's acquisition of the property. In 1838, owner "Saucy Jack" Stoney "lost the house and land in an all-night poker game. The winner: William Eddings Baynard, a wealthy planter from Edisto Island who already owned two island plantations." The Stoney-Baynard house is reported to have looked like this, according to information released by CSA, Hilton Head Island:

> *The rectangular foundation measures 40 feet wide by 46 feet long (1,840 square feet, total), but there is a reason to believe the structures' overall dimensions exceeded these figures. A spacious porch or piazza would have been added to the front entrance of the house or perhaps to its entire perimeter, dramatically increasing the size of the building. Large square holes held the sturdy beams needed to support the porch. Baynard's home faced the marsh to catch the cool breezes blowing from nearby Calibogue Sound. Along the massive*

central hallways, floor-length windows would have adorned the walls on each floor to ensure the cross-venitalation so necessary to comfort in the South.

The remaining portions of the Stoney-Baynard home exemplify a masonry technique called tabby which was popular in the Low Country during the 18th and 19th centuries. Tabby was produced by first burning crushed oyster shells to make lime and then mixing this substance with sand, whole shells and water. When it dried, tabby formed good, sturdy cement suitable for foundations and walls.

Another existing shell ring, 150 feet in diameter, is in Sea Pines—near the east entrance to the Forest Preserve—and dates back about four thousand years. Another Hilton Head shell ring is at the Green Shell Enclosure on the north end of the island, off Squire Pope Road. The mystery of the shell rings may never be revealed; however, that missing puzzle piece only whets visitors' curiosity.

CARICATURES

Although perceptions, understanding and appreciation of caricatures differ from person to person, they were quite popular in publications. These caricatures varied from people to politics to various events. A pen-and-ink drawing published between 1870 and 1928 portrays two black women talking, while an 1888 pen and ink is entitled *Table Talk Below Stairs*. The caption reads:

Dinah: Lord a massy, Liza, be prepared for great 'sturbance in de heabens, chile. Dey's been talking at de dinner table 'bout no mo' p'otection. Massa, he say de would gwine one way, and de sun gwine de odder, and dat it's all got to be fixed next fall at de poles!

An interesting print, published by Currier & Ives in 1864 and entitled *The True Peace Commissioners*, summarizes the caricatures in the following way:

An angered response to false Confederate peace overtures and to the push for reconciliation with the South advanced by the Peace Democrats in 1864.

Confederate general Robert E. Lee and president Jefferson Davis (center) stand back-to-back trying to ward off an attack by Northern officers (from left to right) Philip H. Sheridan, Ulysses S. Grant, David G. Farrague, and William T. Sherman. Sheridan points his sword at Lee, saying, "You commenced the war by taking up arms against the Government and you can have peace only on the condition of your laying them down again." Grant, also holding a sword, insists, "I demand your unconditional surrender, and intend to fight on this line until that is accomplished." Lee tries to placate them, "Can't think of surrendering Gentlemen, but allow me through the national convention in Chicago [which] advocated 'a cessation of hostilities with a view to an ultimate convention of the states, or other peaceable means' to restore the Union." Davis, unarmed with his hands up, agrees, "If we can get out of this tight place by an armistice, it will enable us to recruit up and get supplies to carry on the war four years longer." Farrague threatens with a harpoon, snarling, "Armistice! And suspension of hostilities—Tell that to the Marines, but sailors don't understand that hail from a sinking enemy." Sherman, with raised sword, informs Davis, "We don't want your negores [sic] or anything you have; but we do want and will have a just obedience to the laws of the United States."

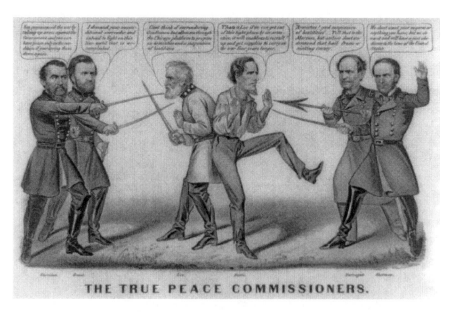

The True Peace Commissioners.

Believe It or Not

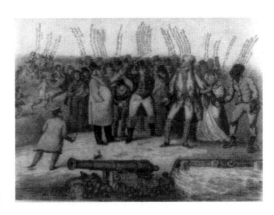

Tensions over slavery.

Another captivating caricature, a cartoon by James Akin of South Carolina, is titled *The Massachusetts Hoar, Outwitted, or Hopping-John, and Johnny Vake, for Cod Fish 'Notions,' Wide Awake!!!* The text must be read carefully for complete understanding:

> *This is an imaginative but puzzling commentary on sectional tensions over slavery between New England abolitionists and southern agrarian slaveholders on the sweeping satire of the artist who portrays a considerable hostility toward blacks as existing among various ethnic groups, including the Germans, French, Irish, and Scott. The title and main conceit here play on the differing regional cuisine: Cod-Fish as the staple of the North and, for the South, "Hopping-John," which he identifies as "Stewed Rice, Cow-Pease, & Bacon a Noble & invigorating dish much in Vogue," and "Johnny-Cake" or "Indian Corn-Bread the stamina of the South." A crowd has gathered at a wharf to witness a confrontation between a man draped from head to foot with cod-fish and onions and a wealthy southerner (center). The former grips the hand of a black youth (far right) and declares "Massachusetts never will relax in her demand, for this gentleman and friend of mine* [i.e., the black man]*, enjoying his rights & protection, in the true spirit and meaning of the Constitution of the United States."*
>
> *A young woman stands at the man's side, her arm around his, and reassures the black youth, "Poor Soul Sir will do all he can to save you, from these wretched varmints." The southerner, who is dressed in white breeches, riding boots, and coat, reacts angrily, waving his riding crop, "There lies your path; be off at once, with that Black Villain for we are resolutely determined to permit no innovations in our Constitution and Sacred Laws*

at the hazard of Life & Fortune." A stout man in the long coat to the left chimes in on the southerner's behalf, "Why you must be a downright Ass to presume that our Sacred Constitution and Laws can be altered to suit your nonsensical Cod-Fish and Onion Notions." The black man, who is barefoot, says to his protector, "Ole Massa I tink wee best go way kase dees Bockara is blongst foh make Swonga dat fashion. But dem hadn't ought foh call you ole ho! Dem is too Cubbitch to gie me right!" Various comments come from the crowed. An Irishman: "Tunder & turf de darm Nagur has nie call wid de Repeal My honey." The Repeal movement was a source of strife in Ireland at the time. A. Frenchman: "Vous etes bougres black dem rasskal. Je ne parle wis un Diable." A German or Dutchman: "Verdam black bases quiesta. Der fisch isch more schtink auer saur-Crout und kast!" A club-wielding Scotman: "A'l noke ye doon ye black veelain gin ye 'mak anither wee whimper." Another man: "Hold your jabbering You black Son of a ----." Several slaves and their master appear at far left. The slaves remark, "Please old massa let me gie that Yankee Nigga one Punch in e gut," "Ole Massa Chase it foh ebery body gwine free," and "Hold you mout you is one dam fool." In the foreground sits a large cannon with mottoes inscribed: "Pro Patria" and "Animis opibusque parati." Beneath the cannon a pile of spilled coins, "Our Blood & Treasure."

An 1861 John L. Magee drawing is a satire on South Carolina's role as instigator of secessionism in the South. The prominent leaders of the Confederate states are portrayed as foxes. The chief fox (the one without a tail) is South Carolina governor Francis Pickens. South Carolina was the most radical of the Southern states and the first to leave the Union.

The cartoon, entitled *What's Sauce for the Goose Is Sauce for the Gander,* depicts opposition to the Fugitive Slave Act of 1850 and presents the following scenario:

In two panels, artist Edward Williams Clay illustrates the abolitionist's invocation of a "higher law" against the claim of a slave owner and the application of the same principle against the Northerner in a case of stolen textiles. In the left panel a slaveholder "Mr. Palmetto" and a federal marshal confront an abolitionist "Mr. Pumpkindoodle" and a garishly dressed, runaway slave "Pompey" in a warehouse of shop interior. On the counter is a copy of the newspaper the "Emancipator." Palmetto: "...I've come

here to take that fugitive slave who belongs to me, according to the provisions of the U.S. law! Officer do your duty!" Pumpkindoodle *(handing a pistol to the slave): "What! Seize my African brother! Never! I don't recognize any U.S. law! I have a higher law, a law of my own. Here Pompey take this pistol and resist to the death! If he attempts to take you!"* Pompey *(trembling): "Ye yes sa! I'll try, cause brudders* [antislavery senator from New York William H.] *Seward and* [abolitionist William Lloyd] *Garrison says it's all right; and so does Parson Squash! But I'm mighty feared."* Federal abolitionist approaches the seated slaveholder in the latter's shop. A sturdy slave *"Caesar"* and a grinning attendant stand by. On the counter are several bolts of fabric, labeled *"Bay State Shawls," "Cotton Shirting," "Domestic Prints," "Amoskeag Ticks," "Lowels Negro Cloth"* and *"Hamilton Long Cloth."* A copy of the Charleston Mercury *lies open on Palmetto's lap. Pumpkindoodle: "Look here Mr. Palmetto them 'ere goods is mine! They've been stole from me, and if you don't give 'em up, I'll take the law of the land on you!"* Palmetto: *"...They are fugitives from you, are they? As to the law of the land, I have a higher law of my own, and possession is nine points in the law. I can't cotton to you. Kick out the abolitionist Cesar."* Cesar: *"Of course Massa. De dam Bobolitionist is the wus enemy we poor nigger have got."*

CHANGING PERCEPTIONS OF WOMEN

Following the Civil War, beginning about 1870, photographers' perceptions began to change concerning the ways they posed African American women for the camera. Instead of slaves wearing turbans and dresses of rough fibers, hoeing in cotton fields, being beaten by masters or sitting on porches of dilapidated shacks, women now appeared groomed, sophisticated and confidant. Their pictures symbolized their newfound freedom, their interests and their poise. Refined hairstyles, jewelry and lace-rimmed dresses replaced burlap skirts and blouses. By the turn of the twentieth century, full-length portraits had become popular. Women, with a lavish setting as a backdrop, posed in beautifully designed dresses and hats. In addition, their posture portrayed their feelings of dignity and self-worth and, at the same time, revealed their interest in books.

An African American woman holding a basket.

A full-length photograph of an African American woman.

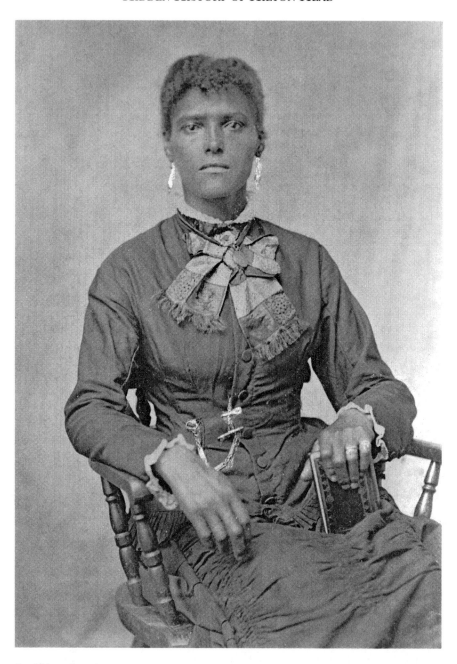

An African American woman, seated.

An African American woman reading a book.

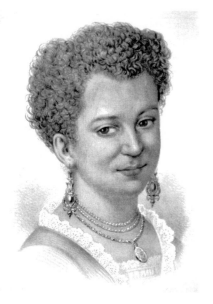

"The Colored Beauty."

"Maum Duck" (Mrs. Doctor).

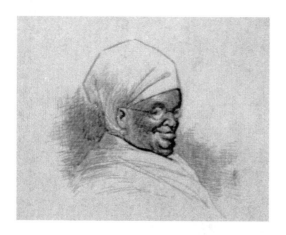

Ole Mammy in Beauty Land.

Women's pictures also indicated their church involvement, their medical expertise and their volunteerism.

The familiar term, "You've come a long way, baby," takes on new meaning when one views the photographs of Ole Mammy and three African American women posed with a prop automobile in a photographer's studio.

PICNIC REUNIONS IN THE LAY-BY SEASON

According to several authors, picnics became the center of church social activity during the summer months, called lay-by seasons. Families often traveled by water to popular picnic sites. Parents sometimes rowed themselves and their children from Hilton Head to the Baptist church in Bluffton.

Speeches became popular after-lunch entertainment. One speaker congratulated his audience on the successful fight with General Green but warned of the coming battle with General Frost. He urged them to adhere to their religion and morals:

> *Be honest, upright and fair, pay out debt, walk straight in the eyes of our fellow-men, do what we can to educate our children, give our attention to hard work, and fit ourselves for all the responsibilities of citizenship which may hereafter devolve* [sic] *upon us.*

Ione D. Vargus, chair of the Family Reunion Institute, has discovered the following truth: "Black families participate in reunions in what I believe are numbers and percentages and with a consistency to which no other group can make claim." With her curiosity piqued, Vargus traveled to the Lowcountry and discovered that the folks involved considered their picnics as "just having a family reunion"; they did not translate this to tradition but to loving care:

> *And so Black people became like other families. They reconnected, engaged in legal marriages, raised children like others and did all the things that were like the white families around them. The system was different from what they had come from in Africa, but they were in a new world. The former slaves faced, of course, the worst kind of discrimination and racism when they were freed, but they managed to raise families...The extended family was crucial. Caring for others with the family structure and community was not only a value carried over from the African legacy, but also a reaction to discrimination and the fact that many social and human services were not offered to the black community.*

Consequently, black Americans still gather for extended family picnics, and the one-day picnic has often grown to a gathering lasting three or more days. Frogmore Stew surely graced many family picnic tables:

FROGMORE STEW

3 quarts water
1 lemon, halved
1 medium onion, halved
2 cloves garlic, crushed
1 pinch coarse salt
1 (3-ounce) package dry crab boil
1½ pounds red potatoes, scrubbed
1 pound smoked beef sausage, cut into chunks
4 ears corn, husk and silk removed
1½ pounds unpeeled, large fresh shrimp
½ cup butter, melted
1 dash hot pepper sauce

Bring water to a boil in a large pot. Squeeze the juice from the lemon into the water and throw in the halves. Add onion, garlic, salt and crab boil. Reduce heat to medium low, cover and simmer for 10 minutes. Add the potatoes and sausage and return to a boil. Simmer covered for 20 minutes. Break the ears of corn in half and add them to the pot; cover, and cook for 10 more minutes. Remove from heat, stir in the shrimp and cover for 5 minutes. Drain off liquid before serving; it may be reserved for other uses such as soup stock. Stir together the melted butter and hot sauce. Serve with the seafood and vegetables for dipping.

Terrible Storm

The Seventeenth Volunteer Infantry, on its way to capture Port Royal, experienced a terrible three-day storm in November 1861. One of the Seventeenth Volunteer infantrymen, Charles Nelson Kent, shares his believe-it-or-not experience. He said that he went to bed next to the ship hospital and could hear one fellow, who had a high fever and was out of his head, repeatedly calling for his mother and singing hymns he had memorized. One that he sang over and over again—all six stanzas—was "Greenville." Although Civil War experts do not agree on the exact words to the hymn "Greenville," some think Samuel F. Smith is the author of the lyrics that the young man sang on his deathbed:

Yes, my native land, I love thee,
All thy scenes I love them well,
Friends, connexions happy country!
Can I bid you all farewell!
Can I leave thee, can I leave thee—
Far in distant lands to dwell?

Home! Thy joys are passing lovely;
Joys no strangerheart can tell!
Happy home! 'tis sure I love thee!
Can I—can I say, farewell?
Can I leave thee, can I leave thee—
Far in distant lands to dwell?

Holy scenes of joy and gladness,
Ev'ry fond emotion swell,
Can I banish heartfelt sadness
While I bid my home farewell?
Can I leave thee, can I leave thee—
Far in distant lands to dwell?

Yes! I hasten from you gladly,
From the scenes I love so well!

Far away, ye billows, bear me:
Lovely, native land, farewell!
Pleased I leave thee, pleased I leave thee—
Far in distant lands to dwell.

In the deserts let me labor,
On the mountains let me tell,
How he died—the blessed Savior—
To redeem a world from hell!
Let me hasten, let me hasten—
Far in distant lands to dwell.

Bear me on, thou restless ocean;
Let the winds my canvass swell;
Heaves my heart with warm emotion,
While I go far hence to dwell,
Glad I bid thee, glad I bid thee—
Native land, Farewell, Farewell.

The second night out, the storm raged so violently that no one could stand or sit or lie still. With all the portholes supposedly closed, this delirious boy, terribly affected by the heat in the closed vessel, moaned and sang. Most of the regiment was awakened by one of the portholes bursting open and water pouring in. After remedying the unfortunate situation, and with the danger over, no one could sleep. Charles Nelson Kent recalled his next moment: "I turned around and faced the bunk of which the singer was lying, but his voice was still...poor fellow! His troubles were over."

When the *Boston Journal* printed an article about the unnamed young man expiring on the way to Port Royal, one of the hospital stewards of the Third Volunteer Infantry said he knew the boy's name—Amasa Niles—and that he remembered the event so well. He recalled that the officer of the day wanted to throw the corpse overboard, but he had protested. Consequently, the young man's body was brought ashore and given a proper burial on Hilton Head.

CAROLINA GOLD

Practically everyone knows of the historical importance of rice in the Lowcountry, and today many folks prepare side dishes for dinner with some type of rice. Few, however, probably realize the tiring and dangerous yearlong process of cultivating rice crops in swampy, snake-infested lowlands. In Hilton Head, slaves began their labor at sunrise to avoid the heat. The work involved several important steps: clearing, plowing, planting, harrowing, hoeing, harvesting and threshing.

Clearing the fields began very soon after the last harvest with plowing stubble into the soil. Harrowing, plowing and trenching were March chores, and oxen or mules pulled the plows. Slaves broke the dirt clods, smoothed the topsoil and dug trenches approximately twelve to fifteen inches apart. Planting began in April. With rice seeds first soaked in mud and dried to prevent them from floating to the top of the soil during flooding, it was now time to plant. Slaves did this by hand, dropping seeds into the ground and then pressing them with their feet. Next came the intentional flooding of the field (known as the sprout flow) until the grain sprouted—usually within three days—and then was drained.

After the rice seeds germinated, slaves returned to the fields, hoeing in tempo with work songs. Another flooding (the long water) killed any insects and grass present. Some of the water was then drained, and the plants grew strong and stood erect. The next stage—called the three weeks of dry cultivation—became a difficult time for the slaves because of the intense heat, humidity, mud and crude hand-made hoes. Mid-July found slaves back in the fields for the final flooding (the lay-by flow), when the ripening rice needed to be kept free of grass and birds. In September, the rice heads ripened and the fields were drained. The next day, the harvest began. Field hands harvested the grain with rice hooks. The rice dried for a day, was tied in sheaves and then was moved to the threshing yards.

The next steps in rice production were tedious. Slaves threshed—or separated the heads from these stalks—by beating the heads off with sticks. Winnowing consisted of separating the grain from the chaff; this was done in specially designed fanner baskets. Next, slaves pounded the rice, removing husks from the grains. Rough rice was put into hollowed-out logs and ground with a pine pestle. Fanning and pounding were both African traditions.

A rice threshing mill.

A winnowing house.

By November, the rice was ready for shipping. Slaves prepared the fields for another cycle of rice production.

During planting, growing and harvesting season, both men and women worked in the fields, but women slaves were not expected to ditch or embank. If a woman slave were pregnant, she was assigned to lighter work, and she was allowed a thirty-day confinement after the birth of her baby. Of course, masters differed in their rules and regulations regarding their rice fields, so what one planter allowed, another did not.

Although some documentation indicates that rice was grown on plantations in Hilton Head near fresh water (with which to flood the crops intentionally), obviously it could not be grown everywhere on the island. An interesting aside concerning the inability to grow rice is included in Hilton Head histories: "In 1836 Rev. Joseph J. Lawton tried to grow rice on Calibogue Plantation in what is now Sea Pines Plantation. The endeavor failed due to lack of freshwater to flood the fields."

By 1850, rice had become the mainstay of the entire Lowcountry economy, with plantations cultivating rice crops known as "Carolina Gold."

The following two rice recipes likely appeared on early Hilton Head tables:

OLD FRENCH RICE PUDDING RECIPE

1 small teacup rice
3 pints milk
5 eggs, yolks separated
Cinnamon
Sugar to the taste
1 tablespoon rosewater
¼ pound butter

Boil the rice in the milk until quite soft. Beat the egg yolks until light; add to the rice mixture. Add the cinnamon, sugar, rosewater and butter. Beat the egg whites until very light and add just before you put the pudding in the oven. Bake ½ hour.

OLD RICE BREAD RECIPE

Take 1 teacup full of soft-boiled rice, left from dinner. Mix with it 2 well-beaten eggs, a little more than 1 pint of milk, as much less than 1 pint Indian meal as you have over the pint milk and 2 tablespoons flour. This will fill 2 middle-sized tin pans and must be baked nearly an hour.

Note: Authentic old recipes, passed verbally from person to person, often did not suggest the degrees of oven heat—probably because that varied from oven to oven.

SEA ISLAND COTTON

Today, we purchase cotton linens, garments and fabrics without a hint of the procedures involved in the production of early Sea Island cotton. According to records, the grandson of the first titled owner of Rose Hill, Sir John Colleton, turned the twelve thousand acres in the Bluffton area into a successful cotton-growing plantation in the 1750s. James Brown Kirk processed 120 bags of cotton worth $13,344 in 1850 and was the second largest cotton planter in the Lowcountry. Furthermore, his crops were considered to be the finest in the South. Kirk had 253 slaves, many of whom probably prepared the cotton for market using the favored methods at that time, according to the following published procedure:

> *Women and boys proved the most efficient pickers. The greatest care is used by them to separate the Cotton, all dried leaves or other substances may impair or discolour the staple. It is then spread, if wet, on a scaffold and exposed to the sun; but, if gathered in dry weather, on the floor in the house, to suffer whatever moisture it has imbided to escape, before it is stowed away in bulk. It is then passed through a patent whipper and sorted in the seed, at the rate of one to two hundred pounds to the hand. It is now ready for the gin…thirty pounds of clean Cotton as a day's labour, are easily turned out to each gin. It is then moted, often, but not always, on frames of wire or latticed wood, at a rate varying from fifteen to thirty pounds to the hand, and is then packed and ready for market.*

Believe It or Not

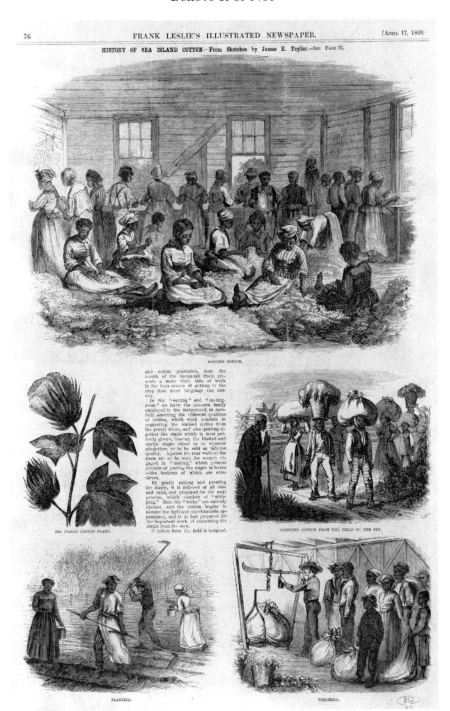

History of Sea Island Cotton (1869).

According to historians, the secret to bumper cotton crops depended on the type of seed planted, so planters experimented "in an attempt to obtain a silky staple." As demands increased for muslins and laces, planters altered some of their methods. For example, they made sure that the cotton was never exposed to the sun but dried inside barns. Finally, sorters removed imperfect fibers and sorted the cotton according to color and quality. In 1844, one planter estimated that he needed fifty-four workers and almost two months to gin a bale of Sea Island cotton—at a cost of twenty-seven dollars a bale.

By 1828, a planter named William Elliot had produced an experimental crop of cotton on Hilton Head:

> *This new hybrid was tall, black-seeded and had a long, silvery fiber well-suited for making fine laces and muslins. The improved staple was welcomed by the English market, and there was an immediate world demand for Sea Island Cotton…and commanded a top price of $2 per pound. By careful seed selection and by using saltmarsh muck and oyster shells as fertilizer, Island planters like William Baynard ensured the continuing success of Sea Island Cotton and realized great profits for themselves. Since the plant could best prosper in the light, sandy soil and subtropic climate of the Sea Islands, Hilton Head Island became a major producer of this long-staple cotton.*

Picking long-staple cotton was much more time consuming than picking other varieties; nevertheless, planters expected their slaves to gather seventy-five pounds of cotton daily.

ALLIGATOR BEHAVIOR

Practically everyone living on or visiting Hilton Head has seen an alligator at one time or another. They sun on the banks of lagoons and swamps, golf course turf and, occasionally, someone's porch. Natives explain how to escape an alligator if one unexpectedly appears: walk away briskly in a zigzag motion; because of their lack of peripheral vision, they walk in a straight line and cannot imitate side-to-side movements.

Alligators breed in April or May with "noisy mating rituals and coupling." Approximately one month after conception, the female lays as many as fifty

eggs in a nest of leaves and mud; however, she never sits on her eggs to avoid crushing them. The rotting materials that make her nest warm the eggs, and the intensity of that heat produces interesting results, as noted in an article entitled "All About Alligators":

> *The temperature of the nest determines the sex of the hatchlings. If the eggs are incubated over 90 degrees Fahrenheit, the embryo develops as a male; temperatures below 86 degrees Fahrenheit result in female embryos; between these temperatures, both sexes are produced. The eggs hatch in two months, producing hatchlings about 6 inches long. The group of babies (called a pod) are protected by the female for about a year. Alligators are among the most nurturing of the reptiles.*

Lagoons furnish meals of tadpoles, frogs, snails, shrimps and insects for the baby alligators. Adults eat these things, but they also devour mammals, birds, turtles and reptiles. They usually feed at night. They swallow their food whole because their eighty teeth cannot tear apart their prey.

Contrary to popular belief, alligators are solitary animals. They associate with other alligators by various calls that are used in mating, mark their territory or indicate distress. When babies are in trouble, they call to their mother by grunting.

Signs on the banks of Hilton Head lagoons warn against feeding or harassing alligators.

TAKE ME OUT TO THE BALLGAME: FORTY THOUSAND STRONG?

Several reports indicate that on Christmas Day 1862 approximately forty thousand people attended a Hilton Head baseball game. The 165th New York Volunteer Regiment (Second Duryea's Zouaves) played against men from other Union regiments (New York Regiment All-Star Nine). This sporting event has been dubbed "an unheard-of gathering of spectators for any event."

In 1862, baseball was not yet considered America's national pastime; however, apparently the sport provided emotional escape and solace during

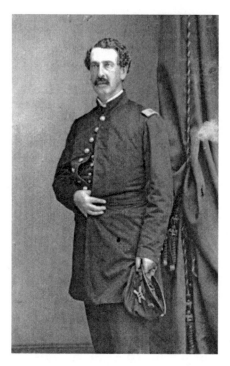

Left: Abner Doubleday (1819–1893).

Below: A tribute to baseball's founder, April 17, 1939.

the Civil War and also brought a common interest between the North and South. One printed response confirms this rather unusual bonding:

Although baseball was somewhat popular in larger communities on both sides of the Mason Dixon line, it did not achieve widespread popularity until after the war had started. The mass concentration of young men in army camps...converted the sport formerly reserved for "gentlemen" into a recreational pastime that could be enjoyed by people from all backgrounds. For instance, both officers and enlisted men played side by side and soldiers earned their places on the team because of their athletic talents, not their military rank or social standing. Both Union and Confederate officers endorsed baseball as a much-needed morale builder that also provided physical conditioning. After long details at camp, it eased the boredom and created team spirit among the men. Often the teamwork displayed on the baseball diamond translated into teamwork on the battlefield.

Research shows that baseball during this period differed greatly from the game we know today. For example, "the Striker (batter) gets to choose where he wants the pitch. The Pitcher must throw underhand. No leading off the bag. No base stealing. No foul lines. All balls are fair." Some soldiers brought their own baseball equipment from home, but most improvised, using barrel staves, tree branches, fence posts for bats and walnuts or cork wrapped in rags for balls. Following are expressions from yesteryear and their modern counterparts:

EARLY EXPRESSION	MODERN EXPRESSION
aces	runs
behind	catcher
club nine	team
cranks	fans
dew drop	slow pitch
foul tick	foul ball
hurler	pitcher
match	game
muff	error
striker	batter
tally	score

A typical 1863 baseball game.

Major Robert Anderson's command. Nine men pose in uniform, including Captain Abner Doubleday (1819–1893), originator of baseball, who aimed the first shot fired at Confederates in the Civil War.

In 1871, nine years after the famous Hilton Head baseball game, the first professional league was officially born, and in 1876 it became the National League. A.G. Mills, who later became president of the National League, played in the famous Hilton Head game on Christmas Day 1862.

This unheard-of gathering of spectators has been called a myth because the huge number in attendance apparently came from A.G. Mills, creator of the myth of Abner Doubleday as the "father of the modern game":

> *Many historians still reject the notion that Doubleday designed the first baseball diamond and drew up the modern rules. Nothing in his personal writings corroborates this story, which was originally put forward by an elderly Civil War veteran, Abner Graves, who served under him. Still, the City of Cooperstown, New York dedicated Doubleday Field in 1920 as the "official" birthplace of the organized baseball.*

Consequently, historical inconsistencies do exist concerning spectators, accolades and exact numbers. One thing remains certain—the game of baseball continued to gain popularity as soldiers went home after the Civil War and organized teams of their own.

PLANTATION MISTRESSES' RECORDED BENEVOLENCE TOWARD SLAVES

Believe it or not, not all plantation mistresses treated their slaves badly, according to Marli F. Weiner in her book *Mistresses and Slaves: Plantation Women in South Carolina, 1830–80*. Weiner chose South Carolina as the basis for her study because this state had more documentary material available. Many rice and cotton plantations—including Hilton Head—had huge slave populations, and the Federal Writers' Project of the Works Progress Administration was what Weiner refers to as an "invaluable but imperfect resource."

One federal project interview indicates that Lucy Gallman had it tough at first. "I was a girl in slavery, worked in the fields from the time I could work at all, and was whipped if I didn't work. I worked hard." Then, her luck changed: "I was put on the block and sold when a girl; I cried and held tight

to my mistress's dress, who felt sorry for me and took me back with her...as fine a woman as ever lived."

Another recorded historical incident explains Miss Sally's unsuccessful intervention when her husband threatened to kill a slave named Leonard. Even a mistress's wrath could not curb her husband's ultimate authority:

> *She run up to Marse Jordan an' caught his arm. Old Marse flung her off an' took de gun from Pappy. He leveled it on Leonard an' tole him to pull his shirt open. Leonard opened his shirt an' stood dare big as er black giant sneerin' at Old Marse.*
>
> *Den Mis' Sally run up again an' stood 'tween dat gun an' Leonard.*
>
> *Old Marse yell to Pappy an' tole him to take dat woman out of the way, but nobody ain't moved to touch Mis' Sally, an' she didn' move neither; she just stood there facin Old Marse. Then Old Marse let down the gun. He reached over an' slapped Mis' Sally down, den picked up de gun an' shot er hole in Leonard's ches' big as you' fis'. Den he took up Mis' Sally an' toted her in he house.*

Part IV

PLACES

SEVEN OAKS

In 1850, at the end of Calhoun Street in Bluffton, Colonel Middleton Stuart built a magnificent antebellum house for himself and his wife, the former Emma Barnwell Stoney. Stuart named their home Seven Oaks in honor of the giant trees on the property. Middleton and Emma fled Bluffton during the Civil War and did not return. Although two-thirds of the town burned, the residence fortunately escaped the fire set by Union troops in 1863. Though the exact date remains unknown, Mrs. Elizabeth Saunders probably opened her boarding house at Seven Oaks in the 1880s. This was the time when Bluffton enjoyed a commercial boom; summer visitors on the May River and salesmen needing a place to sleep and eat probably found her hospitality filled with southern charm and graciousness.

Few specifics about Mrs. Saunders or her establishment exist. This is not unusual because, according to Helen C. Gift in her book *Feeding Generations: Boarding House Fare and Family Oral Tradition*, details concerning nineteenth-century boarding houses and the women who ran them are rare:

> *In a time when women were less well educated, seen as too frail or incompetent to be employed at "men's work"...most women were... domestics, drawing on the skills they had developed in their own homes.*

Women who had space in a house, family resources for property of "start-up" capital, had other options for income such as sewing, laundry or boarding transients…but little appears to be documented about the careers of these women.

Gift goes on to explain that married women seldom worked outside the home; furthermore, when they helped with family businesses, ran a boarding house or labored on the farm, the Census Department rarely received reports of such employment. While there is little recorded nineteenth-century boarding house documentation, certain general facts do surface. First, the women who ran boarding houses did so for a reason. Most of the time, these women needed to support their children, whose father had died. They could earn money as well as stay home with their offspring.

Although we don't know of Mrs. Saunders personal circumstances, it is safe to assume—from historical givens—that she worked diligently from sun up to sundown, preparing and serving nutritious and filling meals, baking special cakes and cookies to sell to the general public, cleaning, changing bed linens, doing laundry (often by hand), raising vegetables and chickens and often a cow in the backyard and enforcing rules that guaranteed the civility and morality of the boarding house.

Nineteenth-century women's recipes were passed down verbally from grandmother to mother to daughter but were seldom recorded. Because of the limited reading and writing skills and lack of treasured paper, women did not write ingredients or directions for their favorite dishes, which often included biscuits, turkey dressing, sweet potato pudding, top-of-the-stove pot roast, fried chicken and, of course, in Bluffton—seafood.

Bluffton's commercial success began to come to a close when the Coastal Highway and the bridge at Port Wentworth over the Savannah River were completed. Riverboat travel and trade dwindled. By the time of the Great Depression, most commercialism had ended. The popularity of Bluffton as a vacation spot remained. Sweet Potato Pone was a popular dish:

SWEET POTATO PONE

2 large sweet potatoes
2 eggs, beaten
1½ cup sugar
2 teaspoons nutmeg
2 tablespoons margarine, melted
1½ teaspoons salt
1 cup dark brown sugar

Peel and grate sweet potatoes. Add other ingredients and mix thoroughly. Pour into greased baking dish and cook in a slow oven at 300 degrees Fahrenheit until done, about 1 hour.

EARLY PLACES OF WORSHIP

Zion Chapel of Ease, an Episcopal church, was built in 1788 for the plantation owners of Port Royal. The old cemetery still remains at the corner of Matthews Drive and William Hilton Parkway.

By the 1840s, black and white people occasionally attended the same church. Seating arrangements, however, were strictly observed. Black families had seats at the back. The men often wore woolen pantaloons, long scarves and white turbans. The women donned bonnets. They all had prayer books, repeating responses and singing hymns—all the while rocking back and forth. White women sat on one side at the front of the church, with white men across the aisle.

Freedom for the blacks brought several more praise houses for each plantation, and now, instead of white ministers, preachers were black men. If no praise house had been built, custom dictated that weekly services be held in the cabin of the "oldest person in the village of negro houses." Traditionally, according to one published itinerary, each meeting followed the same order or worship:

The praise meeting usually opened with a "sperichil" followed by a hymn which the leader "deaconed out" two lines at a time, reading from a well-worn psalm book, if perchance he had learned to read [or] pretending to read, nevertheless, holding the book nearer the flickering light as if to make out the words, all the while calling out the lines from memory...After another hymn and perhaps a spiritual, the leader would ask for a prayer, then read a long passage from the Bible and after another prayer call upon a member to speak. After another prayer and song the "shout" began... Pushing the benches back to the wall and perhaps putting another piece of lightwood on the fire in the hearth and on the one which burned red before the door, the worshipers began the recreation which for the church members took the place of the informal dance.

To become a member of the church, potential members had to seclude themselves for several weeks, at which time they were expected to behold a vision whereby their sins had been forgiven. Then, the praise leader would examine the genuineness of this process, called "seeking." If candidates were, indeed, genuine, they went through catechism classes, memorizing

Negro Church, Smith's Plantation (1860–1865).

each sentence in order to pass their examinations before being baptized on communion Sunday, as reported in one account:

> *Dressed in white robes, the candidates came to the river at high tide to receive the ordinance of baptism...The minister told the church members that they were not to take a long drink of wine, but a sip only—that he had been told that some of them said they meant to get their two cents' worth." (That is the amount generally subscribed by each to buy the wine)...Communion over, the members filed outside to the river bank and amid prayer and song the candidates were immersed.*

As time passed, a few churches joined the praise houses already on Hilton Head. Accounts indicate that the Protestant Episcopal denomination was dominant as the official religion of South Carolina; however, by 1820, the Baptists outnumbered the Episcopalians. After members were converted to Christianity, they refused to attend dances held in various cabins because Baptist missionaries had deemed them evil. Instead, they went to the praise houses, where, ironically, the same gigs were danced to the tune of spirituals.

Sometime between 1860 and 1865, African Americans on Smith's Plantation in Port Royal attended their own church, which eventually became the place where freedmen learned to read and write.

MAGGIONI CANNERY

In 1907, the National Child Labor Committee (NCLC) was chartered by an act of Congress and immediately began to garner support and move toward action and advocacy. One of the first steps took place in early 1908 with the hiring of a tailor's son from Fon du Lac, Wisconsin, a budding anthropologist and photographer named Lewis Wickes Hine. His photographs would awaken the consciousness of the nation and change the reality of life for millions of impoverished, undereducated children.

The Maggioni Canning Company in Port Royal hired many children to work in the business. Some of the children who went to school for half a day shucked oysters four hours before school, several hours after school and eight or nine hours on Saturday.

Above: Some of the children who go to school for half a day and shuck four hours before school and eight or nine hours on Saturday.

Left: Bertha, one of the six-year-old shuckers, begins work at 4:00 a.m.

Bertha and her older sister, father and mother work. All of them make from nine to fifteen dollars a week.

Ten-year-old Sophie "tending the baby" between her jobs of shucking (1912).

Bertha, one of the six-year-old shuckers, began work at 4:00 a.m. at the Maggioni Canning Company. Her parents and older sister also worked there. All of them made from nine to fifteen dollars a week.

Some of those children who shucked oysters also had to tend to the babies of the family. Ten-year-old Sophie took care of her younger sibling between her jobs of shucking. Gusty, an eight-year-old shucker, worked alongside her two brothers.

Gusty, an eight-year-old shucker. Her two brothers also work.

Lewis W. Hine's photographs did change the lives of child laborers. In 1912, one of the first goals of the NCLC was achieved: the establishment of a Children's Bureau in both the U.S. Department of Commerce and the U.S. Department of Labor. From 1910 to 1920, while publishing and disseminating the photographs of Lewis Hine, the committee worked for passage of state and federal legislation to ban most forms of child labor and to promote compulsory education in all states.

HOG BLUFF

According to various reports, the Moss Creek area had several earlier names: Jenkins Island, John's Island, Pope's Island, Tailbird Island and Hog Bluff or Hog Island. For many years, the 315-acre plantation between Skull and Crooked Creeks was owned by the Jenkins family (thus, the name Jenkins Island). No Hog or Hogg (upgrade from the lowly pig) ever owned the property, and although pigs were, no doubt, raised there throughout the long history of the island, Hog Bluff Plantation is one of only three places where Bostwick Devon cows were bred. A man by the name of G.H. (Pete) Bostwick, owner of a polo club and polo ponies, imported and bred these Devon cows. Veterinarian David Roffey explains to the cow novice Bostwick's passion:

> Pete Bostwick imported, owned and bred many of the great sires several generations back in our Devon pedigrees. Imp. Wadhayes Sunshine, Imp. Potheridge President, Imp. Peverstone Pretender and Imp. Tisted Warrant were all brought to the USA by Pete Bostwick starting [in] the 1950s... Topmotley Red Sunset is one of the better known bulls bred by Pete Bostwick and was the first Al Devon sire at the former Curtiss Candy Bull Stud and I think the first Devon bull in an AI stud anywhere at the time.

Perhaps the name "Devon" should be added to the long list by which the island is known.

CAMP SAXTON

The January 1, 1863 Emancipation Proclamation ceremonies were held at John Joyner Smith's plantation, and records indicate that hundreds of freed men and women came from Port Royal, Beaufort and the Sea Islands to join in the festivities marking the event. Colonel Thomas W. Higginson of the regiment wrote, "Just think of it!—the first day they had ever had a country, the first flag they had seen which promised anything to their people."

In a February 7, 1863 article entitled "Port Royal, S.C.," *Frank Leslie's Illustrated Newspaper* presented the following information after advising

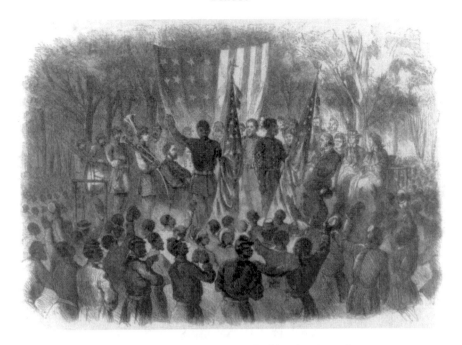

Color sergeant of the First South Carolina (colored) addressing the regiment.

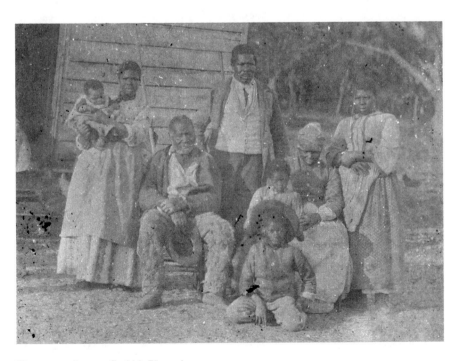

Five generations on Smith's Plantation.

readers, "Our sketches of Port Royal are of a different kind, and show what the authorities are doing to regenerate the sons of Africa":

In our paper of Jan. 24 we gave an interesting picture of the festivities of the colored race on New Year's Day. These were held at Camp Saxton, known formerly as Smith's Plantation. It is the new headquarters of the 1ˢᵗ Carolina Colored Volunteers, commanded by Col. Higginson, who devotes every energy to overcome that natural love of idleness inherent to all inferior or oppressed races. The camp is well arranged, and the men present as soldierly an appearance as Negroes seem to be capable of. Still they do not come up with anything like what the French Turcos are, not yet up to the black regiments of the British West India Islands.

USS *Passaic*: If Its Walls Could Talk

One might suppose that an American war ship has no hidden history because *a ship is just another ship*. If the USS *Passaic*, the "first of a ten-ship class of 1,335-ton ironclad monitors," could talk, what tales it could tell.

Captain Percival Drayton was given command of this first single-turreted, coastal monitor on November 25, 1862. Only two days after the new vessel left New York on November 29 to join the North Atlantic Blockading Squadron at Hampton Roads, it had to be sent to the Washington Navy Yard for repairs. President Lincoln and his cabinet visited the ailing ship on December 6. Finally, on December 29, the *Passaic*, towed by the *State of Georgia*, was on its way to South Carolina. Bad weather off Cape Hatteras, North Carolina, caused leakage, and its crew "was forced to work her pumps and to throw all shot overboard to remain afloat."

It anchored off Port Royal on January 21, and a little more than a month later, the *Passaic*, with assistance from another ship, captured a schooner filled with cotton. By April 7, it had participated in an attack on Charleston, where it suffered severe damage, and had to go back to New York, decommissioned, for repair.

By July 19, it was back in the Charleston area, taking part in battles there. It was decommissioned and repaired time and time again. Miraculously, it, like the Energizer Bunny, kept on ticking.

President Lincoln, writing the Proclamation of Freedom, January 1, 1863.

The monitor *Passaic*, 1863.

In 1863, the *Passaic* helped capture a blockade-running schooner, bombarded Fort McAllister and attacked Fort Sumter. Again, it was sent to New York for repairs. Back in top shape again, the *Passaic* returned to South Carolina waters, and "her gunfire helped to reduce Fort Wagner, on Morris Island, facilitating its capture in early September."

The ship was decommissioned on September 11, 1898, and sold to Frank Samuels the next year.

FORT WALKER

Historians indicate that on November 6, 1861, Confederates counted forty-five Federal steamers and gunboats outside Port Royal Sound. At first, most

masters remained on their plantations; however, soon they and their wives and children escaped in boats, taking only the house servants, nurses and cooks. Apparently, these plantation owners, leaving both Big House and fields, told field slaves to continue with their routine chores while they were gone and "by afternoon, not a white person of Confederate sympathies could be found…on the plantations." This is confirmed by General W.T. Sherman's report after he arrived at Port Royal:

> *The effect of this victory is startling. Every white inhabitant has left the island. The wealthy islands of Saint Helena, Ladies, and most of Port Royal are abandoned by the whites, and the beautiful estates of the planters, with all their immense property, left to the pillage of hordes of apparently disaffected blacks.*

The next morning, November 7, 1861, brought the following firsthand observation:

> *At dawn on the morning of November 7 the "armada," led by the sixty-gun flagship of Captain DuPoint, advanced in battle array upon the two forts with their feeble batteries, twenty guns at Fort Walker and nineteen at her sister fort across the Sound. At 9:25 o'clock a nine-inch gun from one of the forts opened fire. Soon firing was general upon land and water, but the advancing fleet came on safely beyond the range of the Confederate barrage. Passing both batteries, they turned and delivered, in their changing rounds, a terrific shower of shot and shell in flank and front. By 3 o'clock in the afternoon, the Confederate forces commenced retreating to Ferry Point, leaving the Sea Islands about Port Royal Sound in the possession of the Federal Army during the remainder of the war.*

Details differ concerning what happened next. Hazard Stevens, an officer of the Federal army, reported looting slaves who "held high carnival in the deserted mansions, smashing doors, mirrors, and furniture, and appropriating all that took their fancy." He talks of "a black wench dressed in silks, or white lace curtains, or a stalwart black field hand resplendent in a complete suit of gaudy carpeting just torn from the floor."

Other accounts indicate that the slaves continued on the plantations with their regular chores and took only necessities such as sugar and soap from

Gideon Welles, secretary of
the navy.

the master's Big House. If and when they became afraid and suspicious
due to the presence of so many white people, they escaped to the swamps
and woods.

Still another account presents the following scenario: When the Federal
army captured Port Royal, it found that it had also taken possession of some
ten thousand Negroes who might be contrabands of war but whose status
was doubtful, nevertheless. They could not be treated as Northern laborers,
put to work at the camps and then ignored. It was even possible that the
army might, in the last extremity, have to feed and clothe them. But in the
meantime, there were valuable provisions for the army on the plantations
and valuable crops in the fields. So the War Department stepped in to
supervise the sale of cotton and to provide teachers to instruct slaves in the
growing of various crops and teach them to think for themselves.

The U.S. Navy attacked Fort Walker in the Battle of Port Royal, and on November 7, 1861, it fell to Union troops and was renamed Fort Welles in honor of Gideon Welles, secretary of the navy.

HILTON HEAD HEADQUARTERS OF GENERAL DAVID HUNTER

David Hunter became famous after he, without authorization, freed slaves in South Carolina, Georgia and Florida. Major General Hunter, Department

Headquarters of General David Hunter.

of the South, issued the following proclamation (General Order No. 11) on May 9, 1862:

The three States of Georgia, Florida and South Carolina, comprising the military department of the south, having deliberately declared themselves no longer under the protection of the United States of America, and having taken up arms against the said United States, it becomes a military necessity to declare them under martial law. This was accordingly done on the 25th day of April, 1862. Slavery and martial law in a free country are altogether incompatible: the persons in these three States…heretofore held as slaves, are therefore declared forever free.

A Federal army bake house, 1862.

Emancipation of the slaves, proclaimed September 22, 1862.

President Abraham Lincoln, who favored a gradual emancipation, rescinded Hunter's order, and Jefferson Davis, Confederate president decreed, "Hunter is to be considered a felon to be executed if captured."

Despite the president's order, David Hunter enlisted and armed blacks as soldiers for the Union without the consent of the War Department, forming the 1st South Carolina (African Descent) regiment. When angry border slave

A black soldier.

state officials objected and demanded a response, Hunter wrote the following on June 23, 1962, reminding Congress of his authority "as commanding officer in a war zone":

> *The instructions given to Brig. Gen. T.W. Sherman by the Hon. Simon Cameron, late Secretary of War, and turned over to me by succession for my guidance—do distinctly authorize me to employ all loyal persons offering their services in defense of the Union and for the suppression of this Rebellion in any manner I might see fit.*

Hunter's letter did not convince the War Department, and soon he was forced to abandon his philosophy and his plans; however, it was not long before President Lincoln proclaimed emancipation of the slaves. Black men then enlisted in the military.

RED AND WHITE GROCERY

In 1956, Norris and Lois Richardson opened the first supermarket on the island, Red and White Grocery, located near Coligny Circle in the North Forest Beach area. Three years later, Gene Martin bought the store, and the name evidently changed to Piggly Wiggly.

Interestingly, Piggly Wiggly introduced shoppers to self-service grocery shopping. Piggly Wiggly was the first to:

* provide checkout stands.
* price mark every item in the store.
* give shoppers more for their food dollar through high volume/low profit margin retailing.
* feature a full line of nationally advertised brands.
* use refrigerated cases to keep produce fresher longer.
* put employees in uniforms for cleaner, more sanitary food handling.
* design and use patented fixtures and equipment throughout the store.
* franchise independent grocers to operate under the self-service method of food merchandising.

The name change did not affect customer service, and regulars touted the store as having the best products around. In fact, after the name change, old-timers still occasionally made their checks to Red and White or Red Pig, and one newspaper report indicates, "The bank doesn't whimper, much less squeal!"

It's interesting to note specific grocery prices at the supermarket during the 1950s. A family loaf of bread sold for twelve cents; grape jelly, nineteen cents; hamburger meat, eighty-nine cents for three pounds; coffee, thirty-seven cents per pound; apples, thirty-nine cents for two pounds; cabbage, six cents per pound; potatoes, thirty-five cents for five pounds; sugar, forty-three cents for five pounds; and T-bone steak, fifty-nine cents per pound.

Household necessities carried the following price tags: a giant box of Tide sold for sixty-seven cents, toilet tissue went for five cents, toothpaste was priced twenty-nine cents and Lux Flakes cost twenty-seven cents a box.

Reasonable prices accompanied excellent service. In fact, one newspaper report indicated that Gene Martin "gave away more food than he sold. He donated to every charity, every concession stand, every picnic."

He also went beyond the call of duty when he placed special orders for his customers, including those for Braswell's jellies and preserves, Brown Gold coffee, Melitta coffee and filters and John Harris barbecue sauce. He always ordered fresh seafood from Savannah or straight from the shrimping boat of Captain Bill North or from Lester Orage or the Reaves family. His clientele deserved the very best.

Today, the Martins' son, David, is in charge. Although he was only ten years old when his dad bought the grocery store known then as Red and White—with no money down—he recognizes people he has known for the past forty years. Making his weekly deliveries to the Seabrook Retirement Center, David greets customers he knew as a boy. The following is a Piggly Wiggly recipe:

SEAFOOD AND SAUSAGE GUMBO

⅓ cup vegetable oil
5 ounces okra, cut into ½-inch slices
¼ cup all-purpose flour
¾ red bell pepper, seeded and cut into ½-inch diced
¾ green bell pepper, seeded and cut into ½-inch diced
¾ onion, finely diced
1¼ celery ribs, finely diced
2 cloves garlic, crushed
1¼ tomatoes, peeled, seeded and diced
3⅓ cups fish stock or clam juice
1¼ bay leaves
1 tablespoon plus 1 teaspoon Cajun seasoning
Salt and pepper to taste
7 ounces andouille sausage, cut into 5-inch slices
11 ounces large shrimp, peeled
11 ounces lump crabmeat
2 tablespoons parsley, minced
⅛ teaspoon hot red pepper sauce, or to taste

Heat 1 tablespoon plus 2 teaspoons oil in a heavy soup pot over medium heat. Stir in okra and reduce heat to low. Cook gently about 25 minutes, until okra is very soft. Remove okra from pan and set aside. To make the roux, wipe out pan with a paper towel. Add remaining oil and set over medium high heat. When oil is very hot, gradually add flour, whisking constantly as it is added. Switch to a wooden spoon and cook 5 minutes, stirring constantly, until the roux takes on a thick, medium dark brown color. (Watch carefully so the roux doesn't burn.)

Carefully stir in bell peppers, onion and celery. Reduce heat to medium low and cook 5 minutes, stirring occasionally, until vegetables begin to soften. Add garlic and stir 30 seconds. Add okra, tomatoes, fish stock, bay leaves, Cajun seasoning and salt and pepper to taste. Bring to a boil. Reduce heat to low and simmer gently 30 minutes. Add sausage, shrimp and crabmeat. Cook 3 to 5 minutes, just until shrimp is pink and curled. Remove and discard bay leaves. Stir in parsley. Season with hot sauce to taste.

THE VOLUNTEERS IN MEDICINE CLINIC

A huge question asked today concerns present and future healthcare. On Hilton Head Island, Dr. Jack B. McConnell probably asked himself many questions and, through a well-thought-out process and procedure, organized the Volunteers in Medicine Clinic. In his book *Circle of Caring*, Dr. McConnell illustrates, with a true, poignant story, the 1992 impetuses for such a venture:

> *My wife, Mary Ellen, and I retired to Hilton Head Island* [and] *we built our home in a comfortable, gated community, but were surprised when we drove out the back gate straight into actual poverty…I soon made a habit of picking up native-island hitchhikers…In each case I would ask them where they received their medical care. To my surprise and shock, essentially every person said they had little or no access to health care.*
>
> *In a discussion with Dr. Joe Black, he advanced an idea to which I had given some though earlier—using the retired physicians on the Island as a resource for care giving. His reinforcement and encouragement of the idea was very important in starting me on the right path*

Soon, sixteen retired physicians decided to join ranks with McConnell and Black—on the condition that this volunteer ministry could come about without their having to invest their life savings, be exposed to malpractice lawsuits or spend a great deal of money to take the South Carolina relicensing test. McConnell's real work had just begun. While many people doubted that a free clinic would become a reality, others became important allies, including the local media and President-elect Bill Clinton and his wife, Hillary (whom McConnell mistakenly called "Valerie").

Eventually, the initial group of sixteen retired doctors enlisted others, and the Volunteers in Medicine Clinic had over one hundred dentists, physicians and nurses who proudly donated medical services to the needy. Along with the diagnoses came something called dignity.

> *A couple of years after the clinic opened, two fellows in their twenties were walking out of the clinic at the same time as our Director of Development, Jill Briggs. She overheard some of their conversation.*

"Well, what did you think of that?"

"That was the best I have ever been treated by anyone, any time, any place on this Island, and I wasn't even a patient. What did you think of it?"

"I was born and raised on the Island and it's the first time anyone ever called me 'Mister.' And I like it."

On September 12, 1995, Dr. McConnell resigned as chairman of the board of trustees of the Volunteers in Medicine Clinic and relinquished the clinic to those who would continue to provide healthcare to the medically underserved. His resignation letter ended with the following words of wisdom to those who would now take the helm:

With your help it will continue to be a beacon to all who have been rendered invisible and excluded as well as those of us who must learn anew that there is no peace or joy or happiness or health for any of us until there is peace and joy and happiness and health for all of us.

BIBLIOGRAPHY

African American Registry. "Laura Matilda Towne." www.aaregistry.com/detail.php?id=2200.

Alexander, Salley. *Narratives of Early Carolina*. New York: Scribner's, 1911.

"The Archaeology and History of Coosaw River Estates." www.palmettohistory.org/archaeology/Coosaw%20River%20Web%20Page.pdf.

Atlanta Journal-Constitution. "Gullah: S.C. Island Culture Has Roots in West Africa." May 21, 2004.

Atlantic Monthly. "Negro Spirituals: Thomas Wentworth Higginson." June 1867.

Aurandt, Jane. "Hilton Head Island History." HiltonHeadIsland.com. www.hiltonheadisland.com/history.htm.

"Battle of Port Royal." Wikipedia. http://en.wikipedia.org/wiki/Battle_of_Port_Royal.

"Ben H. Vandervoort." Wikipedia. http://en.wikipedia.org/wiki/Benjamin_H_Vandervoort.

"Benjamin H. Vandervoort." Wikipedia. http://en.wikipedia.org/wiki/Benjamin_H_Vandervoort.

"Biography of General Richard Heron Anderson." www.aphillcsa.com/Anderson.html.

"Bluffton Movement." Wikipedia. http://en.wikipedia.org/wiki/Bluffton_Movement.

"Boll Weevil." Wikipedia. http://en.wikipedia.org/wiki/Boll_Weevil.

"Caricature." Wikipedia. http://en.wikipedia.org/wiki/Caricature.

Carse, Robert. *Hilton Head Island in the Civil War: Department of the South.* Columbia, SC: State Printing Company, 1976.

Chew, Robin. Correspondence with Clara Barton scholar, summer 2007.

"Chicken Oscar." Recipe provided by National Chicken Council/U.S. Poultry & Egg Association and www.eatchicken.com.

"Civil War Baseball: Baseball and the Blue and the Gray." Baseball Almanac. www.baseball-almanac.com/articles/aubrecht2004bs.html.

"The Civil War, Hilton Head, and the Evolution of Mitchelville." SCIWAY. www.sciway.net/hist/chicora/mitchelville-1.html.

"Clinton Retreats With Golf, Seminars And Dog Walking." CNN.com. www.cnn.com/ALLPOLITICS/1997/12/31/remaissance.weekend.

"Crab Cakes with Sauce." PigglyWiggly.com. www.pigglywiggly.com/cgi-bin/recipe?id.10487.

"David Hunter." Wikipedia. http://en.wikipedia.org/wiki/David_Hunter.

"Deep Fried Oysters Recipe." OysterRecipes.org. www.oysterrecipes.org/deep-fried-oysters.html.

Dudley, Renee. "Renovated Seven Oaks Seen As Another Visitor Draw to Old Town Bluffton." *Island Packet,* June 9, 2008.

"Emancipation Day Camp Saxton Site." Historical Marker Database. www.hmdb.org/Marker.asp?Marker=20312.

Enchanted Learning. "All About Alligators." www.enchantedlearning.com/subjects/Alligators.html.

"Famous Barnwell's." Barnwell Polymer Technologies. http://members.tripod.com/Dave_Barnwell.

"Follow the Drinking Gourd." www.songsforteaching.com/folk/followthedrinkinggourd.htm.

"Fort Frederick Heritage Preserve." www.beaufortcountylibrary.org/htdocs.../FortFrederick.htm.

"Full Text of 'Poems of American Patriotism.'" www.archive.org/stream/poemsofamericanpatriotism.htm.

Greer, Margaret. *The Sand of Time: A History of Hilton Head Island.* N.p.: South Art, Inc., 1989.

"Gullah." Wikipedia. http://en.wikipedia.org/wiki/Gullah.

"Gullah History." Ultimate Gullah Culture. www.ultimategullah.com/culture.html.

"Haig Point Club: History." Wikipedia. http://en.wikipedia.org/wiki/Haig_Point_Club.

"Harriet Tubman." SPECTRUM Biographies. www.incwell.com/Biographies/Tubman.html.

Higginson, Thomas Wentworth. *The Complete Civil War Journal and Selected Letters.* Edited by Christopher Looby. Chicago: University of Chicago Press, 2000.

"Hilton Head Island History." HiltonHeadIsland.com. www.hiltonheadisland.com/history.htm.

"Hilton Head Island, South Carolina." Wikipedia. http://en.wikipedia.org/wiki/Hilton_Head_Island_SouthCarolina.

"Hilton Head's Stonehenge: The Mystery of the Shell Rings." www.hiltonheadhotline.com/article-Hilton-heads-stonehenge.php.

"A History Timeline of Hilton Head Island." www.hiltonheadislandsc.gov/island/history.html.

"History of Bluffton." Sweerisat. www.sweerisat.com/bluffton-sc/2008/3/7/history-of-bluffton-sc.html.

"History: Early Colonization." Wikipedia. http://en.wikipedia.org/wiki/Charleston_South_Carolina.

"History of Hilton Head Island." www.hhisland.com/history.html.

"History of NCLC." National Child Labor Committee. www.nationalchildlabor.org/history.html.

"History: Verizon Hertigage Classic." *Island Packet.* http://heritage.islandpacket.com/history.

Holmgren, Virginia C. *Hilton Head: A Sea Island Chronicle.* Hilton Head Island, SC: Hilton Head Publishing Company, 1959.

"Hoppin' John." www.southernfood.about.com/od/blackeyedpeas/r/b180308c.htm.

"How to Shuck an Oyster: Easy: Jam and Twist—CHOW." www.chow.com/stories/l0360.

"John Greenleaf Whittier: Facts, Discussion Forum, and Encylopedia." Absolute Astronomy. www.absoluteastronomy.com/topics/John_Greenleaf_Whittier.

Johnson, Guy G. *A Social History of the Sea Islands*. Chapel Hill: University of North Carolina Press, 1930.

Kent, Charles Nelson. *History of the Seventeenth Volunteer Infantry, 1862–1863*. Ithaca, NY: Cornell University Library, 1898.

Larson, Kate Clifford. *Bound for the Promised Land: Harriet Tubman, Portrait of an American Hero*. N.p.: Ballantine Books, 2003.

"The Last to Leave (McLeod's Plantation)." Gullah Tours. http://www.gullahtours.com/leave.html.

Lauderdale, David. "Remember Where Our Community's Bread and Butter Comes From: Local Shopkeepers." *Island Packet*, May 28, 2009.

Laurence, Anya. "Clara Barton's Wartime Love Affair: The Red Cross Lady and Her Colonel Lover." Suite101.com. http://historicalbiographies.suite101.com/article.cfm/clara_bartons_love_affair.

"Limpin' Susan." http://www.chefrick.com/limpin'-susan.

Lockley, Tim. "Runaway Slave Communities in South Carolina." www.history.ac.uk/ihr/Focus/Slavery/articles/lockley.htm.

Maraniss, David. "A Weekend with Bill & Friends; Hilton Head's New Year's Tradition: Name Tags, Networking and Talk, Talk, Talk." *Washington Post*, December 28, 1992.

Martin, Josephine W., ed. *Dear Sister, Handwritten Diaries of Eliza Ann Summers*. Beaufort, SC: Beaufort Book Company, 1977.

"Mastodon (*Mammut americanum*)." Wikipedia. www.en.wikipedia.org/wiki/ Mammut_Americanum.

McConnell, Jack B., MD. *Circle of Caring: The Story of the Volunteers in Medicine Clinic.* Englewood, CO: Estes Park Institute, 1998.

Millen, Patricia. *From Pastime to Passion: Baseball and the Civil War.* N.p.: Heritage Books, 2001.

"Mt. Carmel Baptist Church." Mt. Carmel Baptist Church. www. mtcarmeldale.org/palmetto.html.

"Names in South Carolina." *Institute For Southern Studies* 19 (n.d.).

New York Times. "Benjamin H. Vandervoort, Retired Colonel, 75." November 22, 1960, obit.

"1950's Food and Groceries Prices." The People History. www. thepeoplehistory.com/50sfood.html.

"Notable Residents." Wikipedia. http://en.wilipedia.org/wiki/Hilton_ Head_Island_South_Carolina.

Oates, Stephen B. *A Woman of Valor: Clara Barton and the Civil War.* New York: Free Press, 1994.

"Piggly Wiggly." www.pigglywiggly.com/cgi-bin/customize?aboutus.html.

"Play Ball!" http://magma.nationalgeographic.com/ngexplorer/0310/ articles.

"Port Royal Plantation by Heritage Golf Group." Golfer's Guide. http:// hiltonhead.golfersguidetravel.com.

"Port Royal, SC." *Frank Leslie's Illustrated Newspaper*, February 7, 1863.

Rawick, George P., ed. *The American Slave: A Composite Autobiography.* Vol. 1. Westport, CT: Greenwood Press, 1979.

"Red and White Grocery Hilton Head, South Carolina." *United Energy Associates, Inc.* 10 (Summer 1992).

"The Reformed Reader." www.reformedreader.org/history/love/chapter17.htm.

"Renaissance Weekend." http://www.renaissanceweekend.org/site/aboutus/history.htm.

"Robber's Row." Historical Marker Database. www.hmdb.org/Marker.asp?Marker=16550.

"Robert Rhett." Wikipedia. http://en.wikipedia.org/wiki/Robert_Rhett.

Robertson, Tatsha. "A Path Through Gullah Country." *Boston Globe*, December 1, 2002, M1.

"Robin Givens." Wikipedia. http://en.wikipedia.org/wiki/Robin_Givens.

"Robin Givens Evicted from Posh Hilton Head, SC, Home After Debts Reach Nearly $13,000." *Jet*, February 27, 1995.

"Rose Hill Mansion." www.rosehillmansion.com/James_Kirk.html.

Rutledge, Sarah. *The Carolina Housewife.* Columbia, SC: University of South Carolina Press, 1979.

Salley, Alexander S., Jr., ed. *Narratives of Early Carolina 1650–1708.* New York: Charles Scribner's Sons, 1911.

"Seafood and Sausage Gumbo." www.pigglywiggly.com/cgi=bin/recipe?id.2996. [Recipes on this website change from time to time.]

"Sharecropper Plantations." www.uwec.edu/geography/vogeler/w188/planta3.htm.

"Should the Slave Narrative Collection Be Used?" Library of Congress. http://memory.loc.gov/ammem/snhtml/snintro16.html.

"Shrewsbury Cake, 1808." www.recipezaar.com/shrewsbury-cake-from-eutaw-plantation.

"Siege Artillery in the American Civil War." Wikipedia. http://en.wikipedia.org/wiki/Siege_Artillery_in_the_American_Civil_War.

Sink, Alice E. "Historical Perspective: Lawton Plantation." *Celebrate Hilton Head*, August 2007.

"Slaves of Rebel General Thomas F. Drayton." J. Paul Getty Trust, 2008.

"Slave Wedding History: The Antebellum South." SJB Ministries LLC. www.startum.com/slaveweddings.htm.

"South Carolina Frogmore Stew." http://allrecipes.com/Recipe/Good-Ole-Southern-Frogmore-Stew/Detail.aspx.

"South Carolina Writers' Project: Mattie Hammond Harrell." www.albany.edu/history316/mhharr.html.

"Spirituals, Praise Houses and Ring Shouts." Spirituals Project of the University of Denver. http://ctl.du.edu/spirituals/Religion/praise.cfm.

"The Stoney-Baynard Ruins." Community Services Associates. http://www.csaadmin.com/stoney_baynard.htm.

"Summary and Synthesis of the Plantation Landscape: Slaves and Freedmen at Seabrook Plantation, Hilton Head." Archaeological Excavation Report, 1994.

"Sweet Potato Pone." Chef Rick's Southern Cooking. www.chefrick.com/sweet-potato-pone.

"3rd New Hampshire Volunteer Regiment." Wikipedia. http://en.wikipedia.org/wiki/3rd_New_Hampshire_Volunteer_Regiment.

"Thomas Drayton." Wikipedia. http://en.wikipedia.org/wiki/Thomas_Drayton.

"Thomas Wentworth Higginson." Wikipedia. http://en.wikipedia.org/wiki/Thomas_Wentworth_Higginson.

"Three Dozen Old-Time Children's Games." *Voice* 30 (Spring/Summer 2004).

Tibbetts, John H. "The Salty Dogs: South Carolina Sea Grant Consortium." *Coastal Heritage* 15, no. 3 (Winter 2000).

Tindall, George Brown. *South Carolina Negroes, 1877–1900.* Columbia: South Carolina University Press, 1952.

"The Town of Bluffton: History." www.townofbluffton.com/link.php?link=history.

"Ultimate Gullah-Gullah History." http://www.ultimategullah.com/culture.html.

"USS *Passaic* (1862)." Wikipedia. http://en.wikipedia.org/wiki/USS_Passaic_(1862).

"USS *Passaic* (1862–1899)." www.history.navy.mil/hootos/sh-usn/usnsh-p/passaic.htm.

Vargus, Ione D. "More Than a Picnic: African American Family Reunions." Emory Center for Myth and Ritual in American Life. Family Reunion Institute, Temple University, September 2002.

"Wade in the Water Lyrics." www.songsforteaching.com/folk/wadein thewater.htm.

"War Games: Dec. 25, 1862." Today in Baseball. www.todayinbaseballonline.com/cms/?q=node/104.

Washington, Reginald. "Sealing the Sacred Bonds of Holy Matrimony." Freedmen's Bureau Marriage Records. http://www.startum.com/slaveweddings.htm.

West, Emily. *Chains of Love.* Chicago: University of Illinois Press, 2004.

"Where History Meets Southern Hospitality: The Heyward House." www.heywardhouse.org/hh/history.

Whittier, John Greenleaf. "At Port Royal: 1861." *Atlantic Monthly*, February 1862.

"Who Is Gregg Russell?" About Gregg Russell, Harbour Town, Hilton Head. www.greggrussell.com/about.html.

"William Drayton." Wikipedia. http://en.wikipedia.org/wiki/William_Drayton.

Will, Thomas E. "Weddings on Contested Grounds: Slave Marriage in the Antebellum South." *Historian* 62 (1999).

"Yes, My Native Land, I Love Thee." HymnWiki. www.hymnwiki.org/Yes_My_Native_Land_I_Love_Thee.

About the Author

Alice E. Sink is the published author of books and numerous short stories, articles and essays in anthologies and in trade and literary magazines. She earned her MFA in creative writing from the University of North Carolina Greensboro. For twenty-nine years, she has taught writing courses at High Point University in High Point, North Carolina, where she received the Meredith Clark Slane Distinguished Teaching/Service Award in 2002. The North Carolina Arts Council and the partnering arts councils of the Central Piedmont Regional Artists Hub Program awarded Sink a 2007 grant to promote her writing.

Visit us at
www.historypress.net